Family Pictures

Family Pictures:
A Philosopher Explores the Familiar

Laura Duhan Kaplan

OPEN COURT
Chicago and La Salle, Illinois

Cover photo by Charles Kaplan.

Copyright © 1998 by Carus Publishing Company

First printing 1998

Printed and bound in the United States of America.

Library of Congress Cataloging-in-Publication Data
Kaplan, Laura Duhan.
 Family pictures: a philosopher explores the familiar / Laura Duhan Kaplan.
 p. cm.
 Includes bibliographical references and index.
 ISBN 0-8126-9362-0 (alk. paper)
 1. Life 2. Love. 3. Marriage. 4. Family. 5. Philosophy
6. Kaplan, Laura Duhan. I. Title.
BD435.K284 1998
191– –DC21
 97–17601
 CIP

*For Charles, without whom life might be
possible, but love surely would not*

Contents

Acknowledgments

Many support systems, personal, professional, inspirational, editorial, institutional, and familial, have made it possible for me to take the raw materials of family life and philosophical texts, and mold them into this book.

My friend, husband, and colleague Charles Kaplan, to whom this book is dedicated, both lived and read every essay in this book as it was written. His sharp scholarly editing and loving personal support have been invaluable. My friends and colleagues Judith Presler and William C. Gay read and commented on many of the essays as they emerged during a four-year period. They understood and encouraged the project, even though their own philosophical work has been quite different. Several professional associations, and many members thereof whom I consider my friends, have also been helpful. A few of these deserve special mention: Concerned Philosophers for Peace, Society for Philosophy in the Contemporary World, the North Carolina Philosophical Society, Laurence F. Bove, Elizabeth Minnich, Paul Churchill, Kathy Meacham, Diane P. Freedman, Nim Batchelor, and Yoram Lubling. My volunteer research assistant for another project, Margaritha Harmaty, herself a wise and luminous philosopher, read the entire manuscript of this book and explained to me what I had written.

Several of the thinkers whose work has moved me and whose ideas I have developed in particular essays have read them and provided kind encouragement as well as helpful suggestions, including Sara Ruddick, Richard Cohen, and Susan Brenner. The complex and deeply insightful narrative essays of Vicki Hearne, Susan Griffin, Maria Lugones, and Maxine Greene have

served as models for me, showing me that philosophical texts and personal journeys can illuminate one another. And, years ago, the extraordinary Father Eleutherius Winance brought to life for me the phenomenological texts cited in the book.

Kerri Mommer, my editor at Open Court, provided encouragement and clear guidance through a two-year process of molding essays into a book. I have learned a great deal about writing simply by following her pithy, well-informed instructions.

The University of North Carolina at Charlotte provided the computer environment in which I typed many drafts of this manuscript, as well as the inevitable overload of supplies needed to bring any product into being. Research funded by UNC Charlotte faculty research grants has found its way into the chapters "Mothering and Pacifism" and "Speaking for Myself in Philosophy." Vicki Griffith, paid by the university but always doing much more than she is paid for, helped with mailing, copying, and author-to-editor communications.

The family members and friends pictured on these pages have been my teachers, not simply in the sense that reflecting on their foibles has been instructive, but also in the sense that each one's ordinary words and deeds have illustrated what it means to live with moral ideals. Without their presence in my life, this book would not have been possible.

Finally, I wish to express gratitude for the life of plenty that has made it possible for me to write, and to write optimistically, about my life. While the life I describe is not free of death and tragedy, and my family is not free of strife and confusion, it is a comfortable life. I am aware that it could be otherwise, and am grateful that neither disease, war, poverty, nor discrimination have reduced my family's life to a struggle for survival. Writing from this position of comfort, I have the luxury to conclude that a self fully responsive to others is not

destructive, but is a healthy fact of life. In the face of danger, I might draw a different conclusion.

Marriage

Love's Longing Fulfilled:

Metaphysical Comfort and Plato's *Symposium*

In this book, an ordinary story meets an extraordinary set of texts and the two have a conversation. The story is simple. I marry, become a mother, and watch my parents age. The texts are complex: the *Republic, The Origin of the Work of Art, The Mystery of Being.* Yet the conversation I chronicle in this book is a two-sided one. Through contact with the texts, my story opens out onto large questions of ethics, knowledge, and personal identity. And because the abstract texts are animated by the concrete contexts in which I examine them, they emerge as guidebooks for life's journeys.

As the simple story begins with my search for a lover, so the first complex text examined is Plato's *Symposium.*[1] At the *Symposium* Plato describes, seven drunken men, all professionals, intellectuals, or artists, and one absent woman, a priestess with supernatural powers, deliver delightfully literate speeches about sexual love, mostly, but not exclusively, male homosexual love. But the feast of ideas poses problems for the academically trained philosophical reader, for how is one

to extract the conclusion, the thesis, or the main point, from a tangle of bombastic rhetorical excesses? One method is for the reader to linger on a single speech whose metaphors are rendered concrete by that reader's experience, and to construct an interpretation of the whole that affirms the one idea whose point seems plain. In this essay, I employ that method, choosing the speech the character of Aristophanes makes about our desperate, almost comical pursuit of our "other halves."

The Speech of Aristophanes

Ten P.M. on a weekday night. I, age thirty and single, have accepted my boyfriend of three weeks' invitation to come over to his house. "I can't stay," I tell him, but nonetheless I change into sweats and do stretching exercises on his living-room floor. Soon we sit with our backs against the couch, knees pulled up to our chins, thighs touching. Rock 'n' roll music from our shared musical heritage plays on the stereo as we giggle and chat lightly back and forth.

"You know, it might be possible to live like this," I say. "I know," he says, with a big, shared smile. He knows what I mean! Suddenly his spare bachelor furnishings and bare wooden floor warm up. His living room buzzes with the magical and mystical life of a childhood home. A home: not a house, a physical location, but the very structure of life. A natural habitat, familiar but often not understood or even inquired into: mommy and daddy, intimidating neighbors, ritualized breakfasts, religious ceremonies, seasonal songs, secretly secure and scary places. Already my boyfriend and I have shared meals, religion, songs, and secrets. Around him, I can relax: his habitat could be mine. I am home!

We become lovers and soon we marry. Our lovemaking is joyous, lighthearted. It gives me energy. I describe

it in my journal.

Making love: You touch the other person because you adore them, and the feeling of it on your own skin makes you adore them all the more. You wriggle with pleasure because there's not enough room inside your skin to hold it all. You shudder in order to shake off a little excess happiness so you can be comfortable again, more in equilibrium, so you can go back for another touch or look, to drink in, absorb some more. And the process continues . . .

How different this is from past lovemaking! How different he is from past lovers! Or so my journal testifies. I leaf through it, looking for a vaguely recollected account written the morning after what I, before I found my home, would have called the most passionate night I ever spent:

I can see my face in the glass window. I see thick red lips, swollen and sore from kissing you. I see dark black hair darkened by the oil collected from your fingertips as they touched a thousand nerves in my scalp, your fingers and my hairs ten thousand sea anemones swaying, interweaving. My cheeks are pink recalling my fever, all day before we met, a gray and yellow fever which crept up my cheeks and ears as you came up behind me and finally touched me in a final way. There was no mistaking your intention. . . . I see my eyes, intense, looking for yours as I saw them last night, your lip and moustache a jagged line curling up on one side, the fine lines in your face no longer symmetrical, but rushing at odd angles to and from one another and out of all this, your eyes burning, looking out, clear and white, black and brown in the center, looking at mine. . . . What are we saying, what are we looking for, when we look so closely as such private things are gripping and twisting our bodies? . . . Perhaps this is it: I give my body and my soul up to the universe and to you, in the face of this fine torture.

When I wrote this, I celebrated my sensual experience, brushing aside the nagging emotions flicking at my coattails. As I reread it, I notice my exhaustion: I was swollen, feverish. I thought my senses had been stimulated but now I see they had been drained. I notice my longing: I was looking, burning, rushing, gripping. I thought my desire had been satisfied but now I see it

had intensified. I notice I referred to my pleasures as "private things." It seems I was not sharing myself with my lover. I referred to my sensations as "torture." At the time I thought I was speaking of the physical excitement of riding the edge of an orgasm. But now I see I was speaking of the tragic disappointment of riding full speed towards love, only to be gently bounced back upon reaching a two-dimensional facade. I was like the lovers in the speech of Aristophanes in Plato's *Symposium*, so comical to picture, so tragic to think about. Endlessly throwing my arms around another, wanting us to grow together into a single whole, never quite able to heal the wound of separation that defines the fallen human nature.

The speech of Aristophanes offers a wonderful metaphor for understanding the difference between my love for these two men. With my husband, love is happiness, comfort, the ability to be fully myself. Small separations born of misunderstanding are easily healed. With my old lover, love was longing, sadness, the feeling that myself was never quite good enough. No amount of talking could bridge the separation that left each of us feeling that the other did not want us. The difference, for Aristophanes, is simple: one of these men is my other half, and the other is not.

Originally, says the character of Aristophanes, as he spins a myth about the origin of love, the gods created human beings to be round creatures, with four legs and four arms apiece. So created, the original human beings were quite powerful, with ambitions to match. The gods feared a revolt. To reduce the power of human beings, the gods cut them in half. Naturally these new, incomplete beings longed desperately for their other halves. They spent all their time intertwined with one another, hoping to grow together again. They lost interest in all other activities, including worshiping the gods. This the gods did not like. Therefore the gods invented sexual intercourse, so that human beings, when they

intertwined, could achieve a fulfilling moment of unity and then go back to the business of life. Aristophanes' speech applies explicitly to heterosexuals and homosexuals alike, according to whether their original whole was androgynous, female, or male. According to Aristophanes, it is not the desire for sexual pleasure that attracts people to have sex with one another, but the desire to be whole. "Love" is the name we give to our pursuit of wholeness.

Aristophanes' speech showcases what Joseph Campbell considers the function of myth: conveying the wisdom we need to navigate through the transitions life mandates, in a form that we will welcome rather than belligerently reject.[2] Aristophanes' speech catches us off guard. On the one hand, the ideas seem all too familiar, as the speech strings together everyday expressions we use to talk about love. We say, for example, that a lover makes one complete; that shared orgasm is a fulfilling moment of unity; that in a good relationship one can be fully oneself. On the other hand, the speech of Aristophanes gives us new categories for identifying patterns in our experience that we may not have previously recognized. I noticed, for example, that a lover who fills me with longing may never satisfy that longing, while a lover who makes me feel at home has made the longing that I once thought characterized love seem irrelevant to it. Below I would like to talk about the nature of longing and of love, departing a bit from the language of Aristophanes by calling the pursuit of wholeness "longing" and the experience of wholeness "love."

Longing and Love

Before I met my husband, I longed for love. The longing did not consume me: I worked, wrote, danced, made friends, visited family. But the longing always lurked about, sometimes behind and sometimes in front of, my other activities, dragging me into the discomfort of lead-

ing a dual life. I could have been sitting in my office, organizing, projecting, evaluating, doing tasks which require intelligence and creativity. And yet some part of my intelligence would crowd into my ear and listen for the telephone to ring, revealing the voice of the new lover who could be The One. I could have been in a Hatha Yoga class, trying earnestly to perfect my understanding of relaxing opposing muscle groups, a task which requires full attention; and yet some part of my attention would be drawn to my fellow students, wondering if some potential lover was noticing my body and its skills.

My longing brought with it a split consciousness. More and more often, it seemed, my body just went through the motions of a full and creative life while my spirit longed to be fulfilled, to become part of a larger whole that I conceived of as a loving couple. Each day reminded me of the split between earthly life and spiritual fulfillment. Earthly life appeared unsatisfying, a temporary occupation while I waited for the real happiness. In the meantime the myth of spiritual fulfillment grew grander and grander, appearing as a divine grace that would have to rend me out of the prison of bodily life. As I pursued love, I also pursued snippets of esoteric spiritual disciplines. Perhaps meditation, perhaps nutrition, perhaps a spiritual leader, would suddenly provide the entree for my ascent to a seat on the heavenly choir, from which I could look down at the trivial perspective I formerly called "life."

When love came, my split consciousness disappeared, and along with it disappeared my quest to find spiritual fulfillment outside the boundaries of everyday life. To what aspect of love should I attribute this new consciousness? Should I attribute it to sexual fulfillment? My husband often says that orgasm can feel like leaping off the edge of a ridge into community with some unknown being, far greater than the puny circle of

his own consciousness. His answer would suggest that sex—good sex, that is, wherein our consciousness is not fragmented by fear of performance, fear of our lover, or fear of not getting the grocery shopping done—connects us with the divine, thus quelling our desperate search. But that answer seems incorrect to me, for the more firmly one loves, the less necessary frequent sex becomes. That answer also seems potentially destructive, for it can lead a person who believes it into the tragicomic trap Aristophanes describes, into desperate, sometimes physically destructive, sexual encounters with mismatched partners, as a by-product of the good-hearted attempt to find a niche in the universe.[3]

Should I attribute the new consciousness love brings to the unity of attention it makes possible? Longing for love diverts our attention from the moment, forcing us in every situation to look towards the possibility of finding love within it. This longing keeps us from dwelling in a life and noticing what is wondrous, satisfying, and calming about it. But replacing longing with love frees us to turn our attention towards this other half of life. Here, love for our other half provides an alternative to the monastic tradition. We are able to turn towards God and admire the wonders of God's creation not by quelling our desire for human love, but by satisfying it. Some may object that human love is temporary and therefore unsatisfying. But if that love lives up to the standard set by Aristophanes' myth, it is simply a realization of God's plan, a coupling of pieces perfectly and permanently fitted to one another.

Perhaps I can also attribute the new consciousness that love brings to the feeling of belonging with someone, of being at home, of being able to be fully oneself. Often human beings search for the divine because we do not feel comfortable in the world. But when we find love, we do feel comfortable. No longer must we look for the missing puzzle piece outside of our experience.

Spiritual wholeness is ours, and reminders are manifest every day in such small occurrences as an exchange of smiles, a shared cleaning task, shared pride or dismay over a child's latest adventure. Of course this wholeness can be brutally torn by the death of a loved one, and the feeling of comfort superseded by the experience of utter displacement and disorientation. But at least the fulfillment of love teaches us what is possible, and, after grief subsides, the old vision can return and inform our actions and commitments.

Interpreting the Symposium

In love, we can achieve what Jacob Needleman suggests is the primary spiritual task of a human being, finding a way to live as both a divine and an earthly being, or, in other words, finding a way to realize the divine through earthly things.[4] With this statement, and my conviction that it is at least one of the messages offered in the *Symposium*, I both concur with and depart from Martha Nussbaum's interpretation of the *Symposium*, as articulated in her book *The Fragility of Goodness*.[5] I find the same question asked in the *Symposium* as she does, but I also find a different answer. Nussbaum argues that the main question asked by Plato's *Symposium* is, "Can human beings make a satisfying choice between their earthly or bodily nature and their divine or spiritual nature?" She further argues that the answer offered is, "No: we human beings are both tragically and comically perched between our two natures, and no choice is allowed us." Nussbaum's interpretation lingers on the speech of Alcibiades, as she believes Plato intended for his readers to do so.

In his speech, the beautiful, successful, and famous young general Alcibiades tells the story of his unfulfilled burning desire to play the role of the *erōmenos* (the passive beloved; the young mentored man) to the

philosopher Socrates' *erastēs* (the active lover; the mature mentor) in an erotic relationship. From Socrates, Alcibiades had desired to learn philosophy, the art of becoming a better and wiser person. Yet Alcibiades had also wanted to be Socrates' only beloved mentee. Desperate to get what he wanted, Alcibiades had begun to play the active role of *erastēs*, attempting to seduce Socrates in increasingly intrusive ways, finally arranging for them to sleep naked together. Socrates did not get aroused, and had gently rebuffed Alcibiades, asking, "What do you have to offer me in a relationship?" After recounting these events, Alcibiades, who is drunk, informs all those present at the *Symposium* that Socrates is a phony: though he speaks of erotic relationships, he is not a normal human; rather, he is so obsessed with abstract thought and spirituality that he simply cannot love.

When reading Alcibiades' speech, Nussbaum sees displayed in it the central unresolved tension of the *Symposium:* Alcibiades' intemperate surrender to his body and its emotions clash with Socrates' aspirations towards spiritual purity. Alcibiades' unrequited love is symbolic of the tragedy of human life: we love the divine, the spiritual, which we cannot reach through love.

My own experience of love moves me to reject this description of human tragedy. And my desire to identify with Plato leads me to hope that Plato himself might have also rejected it. Therefore I turn to another philosopher's more optimistic interpretation of the *Symposium*, an interpretation that lingers on a different character's speech. Luce Irigaray focuses her interpretation of the *Symposium* on the speech of Diotima, the only woman (though presented as possibly being a figment of Socrates' imagination) who speaks for herself in the dialogue.[6]

Diotima's speech is probably the most frequently quoted speech in the *Symposium*, and it is the one most

often identified in philosophical conversation as Plato's own view of love, partially because the character of Socrates claims to have learned about love from Diotima. Diotima's most well-known words concern the maturation of the human capacity to love. First a young lover is enamored of one beautiful body; next the lover loves all beautiful bodies; then the lover learns to value people's souls; then to adore the beauty of laws and customs; next to adore knowledge, and, finally, beauty itself. Diotima also explains why people love: to pursue immortality, defined not as an eternal stasis, but as a continuous process of generation. "Love," says Diotima, "is giving birth in beauty."[7] There are many kinds of birthing, in accordance with the many stages of the development of love. One can give birth to children, to institutions, or to ideas, to name a few possibilities. Love, stresses Diotima, is active and creative. It is a spiritual force that is neither earthly nor divine, but mediates between the two, bringing the results of our intellectual and spiritual essays into earthly incarnation, and directing our earthly endeavors towards our spiritual growth.

For Diotima, women's birthing labor is both a kind of love, that is, a giving birth in beauty, and a metaphorical way of understanding what is common to all types of love. This puzzles Irigaray: why, in a dialogue where all but two speakers disdain love for and by women, would the author hold up the love between a man and a woman as the paradigm for transformative, growth-producing love? Irigaray suggests that readers take seriously the weight that Plato does give to heterosexual love, and that we not honor interpretations which ignore the few places in which he does give credit to women.

My interpretation of the *Symposium* follows Irigaray's suggestion as it answers the question Nussbaum raised. Nussbaum asks, "Can human beings make a satisfying choice between their earthly or bodily nature

and their divine or spiritual nature?" I answer: No choice is necessary. As Diotima says, love is a spiritual force that is neither earthly nor divine, but mediates between the two. Some human practices of loving by their very natures mediate between the two, illuminating the earthly as a manifestation of the divine, transforming the human condition into a hospitable one, inviting the practitioners to ascend the ladder of love that Diotima described.

In my case, loving my husband has been such a practice. Together we are ascending up the ladder of love's maturity. Naturally we love each other's bodies and find erotic satisfaction through them. But loving each other has expanded our conception of what counts as physical beauty. Though we may not fit the precise contours of each other's ideal image, we adore each other's beauty nonetheless. As we continue to try to please one another, and to try to solve our shared problems, we develop new levels of appreciation for each other's souls, each other's moral and intellectual qualities, each other's ability to love. As we raise our children together, we develop a growing respect for the customs and institutions that create the context for our children's life, the habits they are learning by rote that will become strengths of character when they reach adulthood. Finally, we are amazed by the knowledge that this process affords us, a knowledge of what it takes to be happy, a knowledge that causes us to ache when we see others lack it, a knowledge that seems to have graced our lives as if an anonymous gift from an unknown source.

It seems that Diotima's myth, as well as Aristophanes' myth, has caught me off guard in more than one way. On the one hand, in reframing my own love according to the terms of the myths, I have come to think of love more reverently, and to recognize the blossoming seeds of the divine within my earthly, everyday routines.[8] On the other hand, I am surprised by how easily I accept what some would call a romanticized portrait of an

unattainable ideal. I am reminded how fruitless is the active search for one's other half, and how dangerous it can be to impose the ideal of perfect unity upon less than perfect situations. The fantasy that romantic love entails a dissolving of distinct wills into a single entity, the couple, has led many lovers to assume that the will should be the man's. Finding themselves suffering in destructive relationships, caused perhaps by this exact misconception, many people infer wrongly that these experiences define love and lose their will to escape. Others distort in the opposite direction, declaring failure the first time active loving is called for, assuming that the necessity for effort implies a failure of unity.

And so I am left with a rather odd conclusion, one I find quite difficult to justify intellectually, but quite easy to identify experientially. When my husband and I contemplate our love, we dwell in beauty, but humbly, because we only know of one way for a person to find their other half. The scientifically minded call it luck. Religious people have another word for it: grace. Truly, as Diotima would say, love is a spirit—at least the kind of love I have discussed in this essay is. No other explanation fits.

Notes

1. Plato, *Symposium*, trans. Alexander Nehemas and Paul Woodruff (Indianapolis: Hackett, 1989).

2. Joseph Campbell with Bill Moyers, *The Power of Myth*, ed. Betty Sue Flowers (New York: Doubleday, 1988).

3. I thank Joe Frank Jones III of Barton College for this criticism of seeking spiritual fulfillment through sexual intercourse.

4. Jacob Needleman, *Money and the Meaning of Life* (New York: Doubleday, 1991). In this book, Needleman is concerned with discovering the right use of money.

5. Martha C. Nussbaum, "The Speech of Alcibiades: A Reading of the *Symposium*," in *The Fragility of Goodness: Luck and Ethics in Greek Tragedy and Philosophy* (New York: Cambridge University Press, 1986), 165–99.

6. Luce Irigaray, "Sorcerer Love: A Reading of Plato's *Symposium*, Diotima's Speech," in *Feminism and Philosophy: Essential Readings in Theory, Reinterpretation, and Application*, ed. Nancy Tuana and Rosemarie Tong (Boulder: Westview Press, 1995), 434–56.

7. *Symposium* 206B.

8. A wonderful novel which explores the quest to find the transcendent in the everyday through, among other means, finding love and taking responsibility is Walker Percy's *The Moviegoer* (New York: Ballantine, 1960).

I Married an Empiricist:
Philosophy and Personal Identity

Even the magical unity of two souls in love can decay under the stress of the social rituals of marriage. Yet dissonances between magical expectations and hard realities can be instructive. My honeymoon revealed quite a gulf between the philosophies my husband and I bring to vacation enjoyment. At the time I reacted to the revelation of differences between us with horror. In retrospect, my reaction is rather comical. None of the dire predictions I inferred from the philosophies we embodied on our honeymoon came to pass. And the dissonance between that expectation and its fulfillment has been most instructive. I have learned that my husband, despite his theoretical orientation towards the world, is a wonderful person. And I have learned that the relationship of theory to experience does not fit a neat hierarchical model in which a few general principles generate a reasonably consistent set of behaviors. Instead, it seems, philosophical theories are one of the many genres of stories that philosophers tell and enact in the process of creating and recreating personal identities and personas. Take my honeymoon, for example . . .

When you think of honeymooning in Hawaii, what do you think of?

- Swimming at the feet of gentle waterfalls?

- Hiking or horseback riding in the craters of active volcanoes?

- Walking in red or black volcanic sand on exotic beaches?

- Snorkeling underwater with brilliantly colored tropical fish?

- Chasing perfectly formed rainbows?

- Buying a bouquet of fleshy tropical flowers for your lover?

- Or toasting your marriage at a resort by the sea?

We did all of these things and more. But somehow, we managed to experience two radically different Hawaiis. He seemed to experience the technological, or the quantitative Hawaii, while I experienced the meditative Hawaii.

One day we went hiking through the woods, up a sharp steep hill of steely grey rock, covered with layers of mud and foliage, in order to score a magnificent view of Maui's Iao Valley. Along the way, I stopped at a stream, crouching down to hear the water's soothing trickle, to feel its icy coolness, healing somehow.

He stopped in a thicket of plants, crouching down with his camera bag to select the best subject and light conditions for a photograph.

After several hours of hiking, and many baths of mud, we got to the top of the hill, a tiny flat plateau no bigger than the kitchen of an efficiency apartment, where we were rewarded with a view of the ocean. In the face of this magnificent view, each of us did something totally incomprehensible to the other.

I retreated into my own thoughts about our surroundings and read a book called *Woman and Nature*.[1]

He set up his tripod, placed his camera on it, and took a photograph designed to show that the relative size of the cliffs we were facing was many times greater than the relative size of the tour helicopter flying by it.

Neither of us enjoyed the scenery—or did we both? After tripping down the mountain, splashing mud around us, we both acknowledged that our hike in the Iao Valley and our time spent on top of the plateau had been one of the highlights of our trip. How could we both enjoy such different things?

He likes getting there. He chooses a goal. He uses maps and extensive cross-references—as many as three tour books. He gathers information about the weather, some common sense for a dedicated weather watcher, and the rest gleaned from the weather radio we brought from home. Then he deduces or constructs the best plan, the best way to get there. Getting there is a verification of the plan. When we arrive, he can pat himself on the back for a job well done. Or, if along the way it turns out that he is wrong, the trip, outing, journey, or project becomes more challenging.

He is constantly taking readings from the sky, the compass, the weather, the maps, the books, and reconstructing the plan every step of the way. This is the fun for him.

I am reminded of Herbert Marcuse's definition of positivism, the scientific thinking that Marcuse worries has come to dominate our culture. For Marcuse, positivistic thinking is thinking that attempts to describe every experience using the language of the physical sciences, and evaluates every experience using the criteria of physical science. A positivist, according to Marcuse, would even ask, what measurable facts prove the existence of God? Marcuse is suspicious of positivism because he worries that it has overshadowed our ability to care about people as unique individuals with mental, spiritual, and moral lives. It has invaded our workplace,

he believes, and has led us to view employees as mere numbers to be factored into productivity statistics.[2]

But let me tell you more about my husband.

After my husband gets to his destination, everything is framed, everything is measured. Sectioned off into rectangles, boxes that the eye of a camera can take in.

And each photo, each view, is measured, is assessed in terms of an amount of light it contains so that the instrument, the camera, can capture it and he can use it. Each scene is assigned a number.

Is it f-11 at 125?

f8 at 250?

Ah! There it is. His understanding of the scene is assimilated to the tool. Does the tool expand or narrow vision? Does it teach one to see things in a new way? Or does it confine one to thinking of, evaluating, analyzing things in the way that will suit the tool?

I am reminded of the definition philosopher Jürgen Habermas gives of "technical rationality." Technical rationality is an attitude towards the world around us as well as a way of thinking about that world. Technical rationality is the way of thinking we invoke when we are trying to invent a technique to reach certain aims. We view everything around us as a potential tool to serve our own ends. We value things not as they are in themselves, and value people not as they define themselves, but only insofar as they can serve our ends.[3] This leads to horrible totalitarian political regimes where people are sacrificed by leaders who try to satisfy their desires for power. When we use technical rationality, we try to dominate our tools. Computer scientist Joseph Weizenbaum has pointed out, however, that sometimes the tools we create come to dominate us. For example, he says, instead of computers being designed to serve human activities, human activities are being shaped to conform to computers. The way we organize our work time, for example, the ways we collect information, have

all changed in order to adapt to our tool, the computer. No longer, says Weizenbaum, are we as free as we think we are. The computer dominates our lives.[4]

I, on the other hand, have a completely different philosophy. I don't get my pleasure from "getting there," from devising the best tools or the best schemes. Instead, I like being there. I like watching each part of the scene until the details grow small and I can take in a larger and larger panorama, until I am transported above the cliffs, behind the farthest rock jetty, and up into the sky, where I am forming the backdrop for the whole scene, it is within me. The spray washing up inside me cools me; and the waves lapping gently beneath my skin calm me.

I am reminded of philosopher W. T. Jones's characterization of the phenomenological movement in philosophy. Phenomenologists focus their attention on human consciousness, continuously asking what events and experiences mean to the people involved in them. Their focus is off the objects outside us and on the thoughts and feelings inside of us. Phenomenologists focus on the interconnectedness of all experiences, rather than isolating individual objects in order to measure them precisely. Phenomenologists feel that every experience contains the seeds of past and future experiences, and so see the fullness, not the separateness, of every moment in our lives.[5]

When I watch the waves, I do a kind of listening. Well, it starts with listening, listening for sounds. But listening intently for sounds is only a way to quiet the body, or rather quiet the chatter between my ears, to focus on something clearly outside me, to deemphasize the visual which we usually watch too closely, and allow to distract us from our other senses. I like to shut down my eyes to half attention, to turn them inwards so that I register as little as if I were facing my own eyelids. Soon it is not sounds I am listening to but vibrations. I allow the auditory to take over.

Did you know that we can use our sense of touch as feelers, much as an insect does? I become more aware of my tactile sensations. Temperature, air movement, light or darkness on the skin. What is going on inside my esophagus, my stomach, how my organs or, as some might say, my nerves are reacting to an environment. I become more aware of my legs, my muscles. I suppose I read my feelings and learn about my environment from them.

I am reminded of philosopher Edmund Husserl's special technique of seeing, listening, and feeling that he called the phenomenological reduction. We have become so unused to looking inwards, he implied, that we need a special technique of doing so. We need to focus on one particular experience, or one particular sense, and bracket off all of our beliefs, all of our preconceptions about what the experience means, or about what is causing it. That is the only way we will be able to look at ourselves with fresh eyes, and see what human experience is really like.[6]

But of course I have not been fair. I am reluctant to admit that my own posturing renders me as ludicrous as I am trying to make my husband appear. I am reminded of, perhaps nagged by, Richard Cohen's critique of Martin Heidegger's version of phenomenological reflection. Imitating Heidegger's response of active listening to the call of what he abstractly names "being" makes it too easy to forget our responsibilities to others, makes it too tempting to lose ourselves in the masturbatory world of endless self-reflection. The only morally defensible phenomenology, says Cohen, is the one described by Emmanuel Levinas, in which we listen intently to the call of other people's suffering.[7] But, of course, I was on vacation, on my honeymoon, and could be forgiven a little listening to being, a little indulgence in pleasurable sensual observation. Or was my indulgence revealing the selfish place to which my attention

naturally turns? Was my husband's indulgence doing the same? If I could forgive myself, could I forgive him?

I learned a lot on my honeymoon, as you can see, about my husband and myself, and also about philosophy. Observing a lived empiricism shocked me out of some old conceptions of philosophy. I had always thought, for example, that positivism, empiricism, technical rationality, phenomenology, and idealism were theories of epistemology, theories about how we gain knowledge. I had thought that we should evaluate these theories by comparing each one with the evidence. How do we actually come to know various things? Do we come to know most accurately by using scientific methods? Is positivism therefore correct? Or do we come to know most accurately by observing our own reactions and ideas? Is phenomenology therefore correct? On my honeymoon I came to see that these academic philosophical theories have a far greater scope than clarifying our methods for the acquisition of knowledge. Whether these theories describe the acquisition of knowledge correctly or not, they are lived. They are guides people use to make decisions about what to do, or about how to decide what to do.

In addition to being epistemological theories, theories of knowledge, pheomenology and empiricism are actually aesthetic theories, theories about what is beautiful, what is pleasurable, about how we enjoy ourselves in life, about what we prefer to see, about what we would do with ourselves if we had a two-week vacation on an exotic island. They are *values*. Like monetary values, they tell us what pleasures we would be willing to pay for. Like color values, they tell us what looks good, what balances and harmonizes. Like numerical values, they tell us what persons, procedures, and events to weight most heavily in our deliberations. But naming the theories "values" does not automatically point us towards a calculus for understanding them. It does not

make one essential salient feature the key to analysis. Values do not, cannot, float about unattached, ready for observation. Most of the time, in fact, they are not even taken far enough out of context to be articulated. They are simply expressed through our activities and our judgments, through our thematizations of who we are and why we act. Not only is an epistemological theory also an aesthetic theory, but an aesthetic theory is also an ethical theory. None of the theories we hold is entirely separable from the decisions we make (or, in many cases, fall into) about who we are and who we hope to become. This is why I was terrified of, and for, my husband. I worried that his empiricism, his positivism, his affinity for technical rationality, would guide his ethics, and that he would reduce people to quantifiable tools for use in his schemes.

But, as so often happens in the course of philosophizing, I was interrupted by the call of real life, specifically, the reality of a relationship. Over the years, my husband has not turned out to be an ethical monster. In fact, he is exceptionally sensitive, humane, respectful of the freedoms of others. So I am left with the puzzle: How could someone so wonderful embody such terrifying philosophies? Can it be true that, although ethics, epistemology, and aesthetics all guide lived decision making, that process of decision making is not a monolith, tyrannically supervised by a single reigning value? Perhaps it is time for me to reevaluate my understanding of philosophy, and to begin to understand it in the context of life.

What is a life? To ask the traditional philosophical question, what is the essence of a human life? It is difficult to generalize about what aspect of life forms the core of human identity. As phenomenologist Gabriel Marcel notes, no one indicator suffices to characterize the essence of any individual's identity. We cannot judge a person solely by their job, journals, family, creative

productions, religious professions.[8] We do not know whether body, soul, or mind is the essence of a human being; we do not know whether the essence of a person is more accurately characterized by inner projections or outer behaviors. Nor is the relationship between inner projections and outer behaviors simple. It is analogous to the relationship between past, present, and future, as phenomenologist Maurice Merleau-Ponty describes it.

According to Merleau-Ponty, a person constantly reinterprets the past, always lives in the present, and continuously projects a new future.[9] We act in the present, sometimes with and often without a clearly understood purpose. But as we think about our action in relation to the future we project for ourselves, the past action may take on an entirely different character. In a sense, a person's self-concept is always part fiction and part reality, including sometimes random actions placed in the context of an internal story about the actor's life.

I fear that in judging my husband so harshly and so hastily on our honeymoon, I confused his fictions with his realities, his internal story with his external behavior in a relationship. On the honeymoon, I saw only his favorite story about his reigning philosophy of life. And why not? He was on vacation. Vacation is fantasy; crises do not intrude; away from home, in a new place, we can for a time choose the script we wish to play out and control the action. In this context, his wish to play the scientific conqueror of the exotic island Maui should have been no more threatening than my desire to play the wandering mystic. In real life, and particularly in situations that call us to respond to the suffering of loved ones, I do not let responsibilities slide and organized projects decay and he does not use his family, colleagues, or friends as cogs in his highly structured plans.

For example, when my husband's mother was clearly close to death, hospitalized for what might well be the

last time, he dropped all his carefully worked-out plans for the next several weeks of work and family in order to travel eight hundred miles to be with her. "Duty" was the only reason he gave. But after he arrived at his mother's home, he quickly repatterned his understanding of the trip so as to feel proud and confident, not scared: "I'm here to talk in person to the doctors and find out what is really going on." The ethical thing to do, he reasoned, given his particular talents, was to contribute to the family his ability to learn, understand, interpret, and plan. Part fiction, part reality, continuously projected into the world around him.

My husband's guiding story takes the form of a philosophy. Perhaps much of what I have said in this essay about personal identity also describes philosophy. Like our stories, our philosophical theories are more or less true, continuously projected and tested, but never entirely accurate. As philosophers know well, anyone bent on discrediting a philosophical theory can find a counterexample, a situation in which the theory appears inaccurate. Yet the search for a consistent philosophy continues, and academic philosophers are still trained to pursue consistency through rational argumentation. Perhaps that pursuit is born of the same aesthetic impulse that reinterprets our actions in the light of a reigning self-concept. It pleases us that our thought conforms to a particular pattern, a pattern we can articulate and defend with pride, a pattern that suits our personal style of living. Perhaps, on the other hand, the pursuit of consistency is born of the same ethical impulse that inspires us to attend to conscience and regrets, the nagging voices of competing storytellers within us, challenging our dominant stories. If this is the case, we may never find a single theory that fully accounts for an area of inquiry, just as the best personal accommodation we can make sometimes includes living with regrets.

I take quite seriously the analogy between stories about personal identity and philosophical theories. Both articulate ways of organizing information and experience. In fact, I see more than an analogy between the two. A philosophical theory may well be an expression of a story about personal values, told according to the disciplinary conventions of academic philosophy. Certainly my husband's and my stories about our relationship to the land of Hawaii closely resemble some well-established academic philosophies. If philosophical theories are stories, then it is simply honest to tell them as such. It is also risky to do so. Stories often have holes in them, cracks through which a variety of interpretations may peek. A theory situated within the story of its genesis provides more opportunities for self-critique as well as critique by other, not necessarily formally trained, philosophers. If truth, rather than theoretical elegance, is the dominant goal, storytelling may be worth the risk. A story about which I am ambivalent, coupled with the philosophical theory I tentatively use to interpret it, may express truth far more fully than a simple statement of the philosophical theory.

To make a bad pun, and to exonerate my wonderful husband, the theory doesn't tell the whole story.

Notes

1. Susan Griffin, *Woman and Nature* (Harper and Row, 1978).
2. Herbert Marcuse, *One-Dimensional Man* (Boston: Beacon Press, 1964).
3. Jürgen Habermas, *Knowledge and Human Interests,* trans. Jeremy J. Shapiro (Boston: Beacon Press, 1971).
4. Joseph Weizenbaum, *Computer Power and Human Reason* (San Francisco: W. H. Freeman and Company, 1976).
5. W. T. Jones, *The Twentieth Century to Wittgenstein and Sartre,* 2d ed. (New York: Harcourt Brace Jovanovich, 1980), 250–54.

6. Edmund Husserl, *Ideas: General Introduction to Pure Phenomenology* (New York: Macmillan, 1956).

7. Richard Cohen, *Elevations: The Height of the Good in Rosenzweig and Levinas* (Chicago: University of Chicago Press, 1994), 287–96.

8. Gabriel Marcel, *The Mystery of Being* (Chicago: Regnery, 1950), 148–70.

9. Laura Duhan [Kaplan], "Ambiguity of Time, Self and Philosophical Explanation in Merleau-Ponty, Husserl and Hume," *Auslegung* 8, no. 2 (1987):126–38.

I Wouldn't Hurt a Flea:

A Moral Dilemma in Housekeeping

Setting up my own home under the watchful eye of philosophical tradition has not been easy. Even simple tasks such as flea control are fraught with moral and philosophical dangers.

My Moral Commitment to the Sanctity of Life

Lately I've been looking at insects a lot and drawing analogies between their psyches and my psyche with greater and greater ease. When I look at an insect, I look at a creature who thinks and feels. So when an insect enters my house, I treat it with a full measure of respect. When I hear a mosquito circling me, pinpointing the most succulent piece of my flesh for a meal, I simply wave the mosquito away. Spiders with webs are allowed to stay until, bowing to the expected preferences of my human guests, I escort them out when I'm cleaning for company. I trap the spiders in a special tumbler made of bubbled glass, and relocate them on

the front or back patio. I've even started doing this with flies—they can't see the bubbled glass coming at them from behind. I did it once in the middle of the night with a luminous green moth decorated with smooth swallowtail wings, though one wing was tragically torn by the teeth of the cat who had carried it in its mouth. I've done it with ants, crickets, even a roach. Bees and wasps still frighten me, however. When I see one of them flying towards the light by bouncing systematically along my kitchen window, I try to open the window. At worst, I let them be, figuring they'll retrace the way they came in. But I'm almost ready to try using the bug glass on them—as long as I wear my padded work gloves!

The Deteriorating Domestic Situation

Four cats live with me and my husband. When a cat grooms, scratches, shakes its head, and sometimes just gets up from lying down, it leaves a little trail behind it of barely visible black and white spots. The black spots are flea excrement (called "flea dirt" in the vernacular), little curls of dried cat blood, minus whatever nutrients the fleas have extracted. The white spots are flea eggs. Millions of white spots, millions of eggs. I'd been seeing more black and white flecks than usual. The cats were scratching more than usual. A cat would take a step, interrupt herself, sharply land on the ground and like lightning turn her head to her tail to catch a flea. No sooner would she get up but she would collapse down again to lick strenuously under her arm, soothing a flea bite. Up and down, round and round, in ninety-degree heat and humidity. To escape the discomfort of the fleas, our cat Cloud (who is perpetually irritated with everything and everybody) sought high ground—top of the refrigerator, tables, kitchen counters—scattering flea eggs and flea dirt on our eating and food-preparation

surfaces. Sissy (nicknamed the "Space Invader") had to take over Cloud's new territories and she too started climbing on our food-preparation surfaces, scattering more flea eggs and more flea dirt. Luna (the two-year-old kitten, sweet but somewhat dimwitted) simply imitated her elders. And Yogi (the smartest cat) recognized that others were breaking the rules, so she might as well take advantage of the opportunity. All of this meant that flea eggs and flea dirt were being scattered everywhere in our house. So every time a cat settled somewhere smooth and cool (such as the tiled kitchen table) we'd run towards it and shout. Our efforts were futile, of course: we were like foreigners running towards a missed train, shaking our fists, shouting in an irrelevant language. The cats were upset and dealing with it as best they knew how.

Late one evening I put on soft music and lay down in the semidarkness of our carpeted den. I breathed deeply, told my body to relax and began some very gentle yoga exercises. I was interrupted by a sharp stinging!—a loud, quick ouch!—on my foot. A flea had latched on. I removed it (I don't remember if I killed it or not) and sank back to the floor. Suddenly my arm was stinging. I removed another flea, frustrated now, not merely annoyed. I went to bed.

At 2 A.M., maybe 3, I got up to pee. When I sat down on the toilet under the harsh bathroom light I saw that each of my feet had five black fleas on it. Tiny fleas, baby fleas, wobbly fleas, to be sure, fleas that hadn't latched on to dig their suckers in yet, but fleas nonetheless. I had to fight my disgust. Quietly, I went back to bed. Minutes later, my husband, awakened by my stirrings, got out of bed and went to the bathroom. Seconds later I heard a moan of dismay. He is usually a heavy sleeper, but he was wide awake now, and shouting. "Disgusting! Ugh! They're everywhere! How'd they get in the bathroom? They're supposed to live in carpet! The floor

is crawling with them! You can see them against the tile," he wailed. (I looked the next morning, early, and in fact the floor was not crawling with them—but perhaps twenty were visible across the room, hunkering down, crouching and shaking, bodies buzzing a bit with the heat of life, the frenzy of not yet having a host and waiting, newly pupated on the cold stone floor.) "I'm totally grossed out!" my husband said. Fighting to keep my moral principles in use, I said, "They're not disgusting, honey, they're just insects." But really I was disgusted too, and frustrated. My legs were covered with flea bites. That morning I began spraying my feet with Cutter's before getting out of bed. Cutter's is a mild insecticide, popular with hikers, which repels but doesn't kill bugs.

Objective Description of the Enemy

Fleas are parasites. They take and take and take from their hosts, and give nothing in return. Flea eggs can lay dormant for years until climatic conditions are right for hatching. Adult fleas can live a full generation—and reproduce themselves—without ever eating. A cat can literally be crawling with fleas drinking its blood through little holes bored in the skin at the roots of its hair. A cat will try to trap the fleas in between its teeth and remove them. As a cat grooms itself, it ingests flea eggs. The flea eggs do not dissolve in the cat's digestive juices! Instead, the eggs hatch in the cat's intestines, where they grow into oversize larvae called tapeworms and drain the cat of its nutrients.[1] A cat with tapeworms will lose weight as its appetite increases. And of course flea bites itch on both cats and humans.

Sometimes I'll pick a flea off a cat, or one will accidentally jump from a cat to me. I know I can kill it by rolling it between two fingertips. But then I have to feel it against my skin and I feel closely implicated in the

killing, as close as my fingertips are to one another. I know I can kill it by scoring it and then breaking it in two with my fingernail. My fingernail is more like a detached weapon. But that's brutal and there's a crunch and sometimes a leakage of blood. I've tried to drown fleas in the sink under running water, but often it doesn't work. The fleas swirl around in the ripples, their little legs kicking frantically. And they always regain their consciousness and their full physical prowess as soon as they've made their way out of the water. So a lot of the time, I just let them go.

A Justified War Begins

While the cats' discomfort level was rising, I had known that disaster was on its way but I chose to ignore it, in the hope that it would turn around and leave before it got here, partly because I didn't want to be bothered and partly because I wanted to avoid killing fleas if I could. But now I had to do something, so the intervention I chose was "pro-ban." Twice a week I tricked the cats into eating an insecticide pill by stuffing it into a cat treat. When fleas bit the cats, the fleas would die. This way, I could begin to protect the cats without directly killing any fleas myself.

But as I've told you, by the time I moved to protect the cats, fleas were hatching everywhere. No sooner would a flea bite a treated cat and fall off than another one would climb on. And we had to protect ourselves. So I purchased "siphotrol plus II house treatment." The label says, "with Permethrin & PRECOR insect growth regulator. Kills visible adult fleas. Stops hatching eggs from developing into adult fleas for 30 weeks." I thought that was pretty cold language: "insect growth regulator." Try "insect egg smotherer."

I started in the bedroom, spraying an extra-heavy dose of siphotrol in neat rows. I tried to use the tradi-

tional philosophical criteria for conducting a just war[2] as a set of instructions and to spray systematically, holding no malice towards the fleas. I peered nearsightedly at the yellow carpet as I sprayed, hoping not to catch sight of any fleas. Fortunately, I saw none. I had the best of both worlds: I knew I was killing them, as I had the right weapon, the strong poison, but I didn't have to see any of them dying. I completed the task with distaste.

Two days later I saw a dead flea on a kitchen counter. I was pleased. Our intervention was working! That evening I saw a live flea hop on my bed. I was annoyed and frustrated. The chemical hadn't worked. All that work I'd put in, emotional and physical! But I set my emotional regulator on low, suppressed the feelings, and tried to feel matter-of-fact about the project. I knew I hadn't finished the house; I knew it took a long time. Sadly I reaffirmed my grudging commitment to finish the job. I know my husband was eager to be rid of the fleas, so I didn't speak of my sadness, but he saw it on my face. He sympathized with me, saying, honey, I know you don't relish killing insects—and then began to offer reasons why it was necessary to do so. The cats are uncomfortable and we took on the responsibility to care for them; our legs are covered with bites and we have a responsibility to keep ourselves in good health; we can't have guests in a houseful of fleas and it is our duty to make our friends and our family comfortable—but he stopped, recognizing my sigh of agreement, tinged with sadness. This exchange took place over and over.

The Moral Costs of War

I found fleas in my husband's car. Each time I sat down in the passenger seat for the commute to or from work, I felt the stinging pain. A flea had leapt on my bare skin and latched on. One particular time, I picked the flea off as usual, holding it between the fingertips of my thumb

and forefinger. Still trapping the flea, I moved my thumb a fraction of an inch, and bent my knuckle to press my thumbnail into the flea's body. I cut off its rear. The flea was still quite alive, and it jumped. I trapped it again, and cut off more of its body and its back legs. Some blood leaked onto my forefinger. To my horror, the flea struggled to jump away. I thought of the flea's pain, possibly dulled by the adrenalin rush of struggling for the safety of its life. "Mercy killing!" I shouted inwardly, "I need to put this flea out of its misery." I tried a third time to sever its lifeline. The flea continued to kick and to summon the strength and leverage to jump. Frightened and shaken by my incompetence, and disgusted by the suffering I was causing, I rolled down the car window and flicked the flea out. Instantly I regretted doing so. I thought of the dismembered flea lying on the hot pavement, rattled and deafened by passing cars which somehow always seemed to miss it, not being willing to wait to die, and struggling, possibly for days, as a hardy flea might do. I turned to my husband, wanting to express my confusion, my sadness, my pain on behalf of the flea. But I saw his face, intent on the perfectly ordinary task of driving. He would find my words absurd. Tears stung the corners of my eyes and trickled down my face. I realized that there are some things one just does not say.

Epilogue: Up the Phylogenetic Scale

As I was vacuuming flea eggs, I saw a wasp buzzing and bouncing against a window. It occurred to me (dispassionately of course) that one could get rid of the wasp by simply sucking it into the dustbuster. One could even, theoretically, take it outside and let it free, though one probably would not. The wasp's delicate wings and legs would become entangled in the dust fibers and its eyes would fill with dirt. If one continued to vacuum,

more dirt would press upon the wasp and it would die a horrible death. If one were genuinely "dispassionate," but looking for effective ways to kill with the tools at hand, this scenario would sound possible, even plausible, and would generate a mild pleasure—not at the suffering of the wasp, of course, but at a job well-done, at ingenuity exercised and vindicated. Being "dispassionate," I fear, means being dispassionate about the blood you're shedding, the flesh you're tearing, the eyes you're blinding, the thoughts you're silencing, the fear you're escalating.

Notes

1. My veterinarian, Dr. Hardin Rubin, has informed me that this is not a correct account of the life cycle of the tapeworm. Nonetheless, I have left it in the text for shock value.

2. These criteria were originally developed across several works by Augustine of Hippo. For a tracing of the development of these ideas, see Warren Harrington, "Augustine's Stance on War," in *From the Eye of the Storm*, ed. Laurence F. Bove and Laura Duhan Kaplan (Atlanta: Rodopi, 1995). For a modern enumeration and understanding of the criteria, see Duane L. Cady, *From Warism to Pacifism: A Moral Continuum* (Philadelphia: Temple University Press, 1989).

Adult Daughter

Her Silks, Her Self:
Property, Identity, and Death

My mother-in-law died a scant four-and-a-half years after I met her, three years after her diagnosis, three years after her beloved husband's death. She died of cancer, a slow deterioration imperceptible to outsiders for the first two years, but no doubt emerging inside her as a long muffled cry, "What is happening to my body?" Reaching out to familiar persons, to the rituals and activities that had been her life, she found them shrinking ever so slightly from her touch. Confused, slightly off balance, but not focused enough to be enraged, she wondered, silently at first, then later out loud, "Why is my life slipping away from me?"

I don't know how you answer someone older and supposedly wiser than yourself, someone who showed you how to bathe your baby, who with a gracious aphorism revealed to you how to make your husband's cotton shirts come out of the dryer wrinkle-free. So I didn't answer her. Instead, I visited with her, advised her on experimental medical treatments, sympathized with her when my husband scolded her, entertained her with gossip as her muscles wasted away, distracted her from her

nausea with tales of her granddaughter's latest triumphs, made fewer and fewer demands on her as I saw her abilities decay. And I said "I love you" much more often.

But I was angry with her, too, angry because I wished she had the depth to answer her question herself. Years ago, my counseling of a student who had been raped by a stranger convinced me that there is a difference between people who are "deep" and people who are not. This student was deep—she had within her the resources to separate and then reweave the strands of her powerful feelings, to balance anger and forgiveness towards her assailant, to think clearly about the changes indicated for her life and plan for them. My mother-in-law, I'm afraid, was not deep. She lived much of her last three years in a tangle of fear and loneliness, too angry to be accepting, too confused about what acceptance means to think about how to move gracefully towards the horizon of death, desperately trying to grasp onto shards of her old life.

While raising four sons, she had become a beautiful socialite, finally retiring to a country club with her second and very-much-loved husband. In the last three years of her life, beginning months after she had turned sixty, she lost her husband, her beauty, her athletic ability. She even lost some of her friends. Her response was to date, diet, and dream about playing golf. I was angry that losing those things left her so alone, so resourceless. "Is that all there is to you?" I wanted to ask, shaking her. Have you no shred of yourself that isn't tied up in these things? Is there no voice inside your head that can take account of the losses and advise the part of you that transcends them? I no more understood my mother-in-law than she understood me. How could a smart person choose to make no efforts at self-reflection? Why was she making life harder for herself by shutting out opportunities for insight and change?

In retrospect, I am embarrassed about my anger. What arrogance informs it!? Why, the arrogance of a grand tradition, beginning with our patron saint of philosophy, Socrates, who said, "The unexamined life is not worth living." My mother-in-law led an unexamined life, devoid of any but the most superficial self-reflection. Was her life—a disciplined life, directed by the canons of order and good taste, enacted on a stage of beauty and wealth—not worth living? Surely it was; but I can only make peace with that fact if I equivocate on the meaning of "self-reflection." Perhaps my mother-in-law did not have mental mirrors that showed each other their reflections, offering their emotions and thoughts for evaluation. But she did have a host of tangible mirrors surrounding her: her apartment, her clothes, the art objects she cherished.

I learned a lot about my mother-in-law after she died, going through her personal effects. I learned that she held closely the things her children cared about, when I found copies of my academic articles in the drawer by her bed, and loving cards my husband had sent her tucked in among her sweaters. I learned that she was nostalgic when I discovered that each of her dress-up purses held memorabilia from the parties and restaurants it had visited. I found menus, place cards, the script of a skit honoring a friend, and the program for her husband's funeral, each in a particular purse. I learned that she was a skilled writer of emotionally evocative prose as I read some of the letters she had written in the last three years: a formal complaint to a dating service, a generic thank-you note to loving friends who sent cards and flowers during an early hospitalization, a speech asking her fellow country-club officers to stop conjecturing about the progress of her disease.

I learned about her self-image when I collected and inventoried her clothes for donation to a thrift shop.

She was a shrewd shopper: I found silk scarves still bearing a 75%-off tag. She was definite in her self-assessments: several times I found multiples of the same shirt in four different colors. Though beautiful, she was not playfully sexy: among fifty very functional looking bras I found only one lace teddy. She was exact and exacting: to my trained eye (but not of course to the eyes of my husband and his brothers) each pair of dressy shoes on the shoe rack had a belt to match on the belt rack, a purse to match on the purse rack, and a particular dress which all accessorized.

Guided by political philosopher Iris Marion Young's essay, "Women Recovering Our Clothes,"[1] I have come to a better understanding of why many women tie their personal identity so intimately to their clothes. Young first toys with a radical feminist explanation. In our society, what sort of creatures women must be is decided by men; therefore women dress in order to appear to be what men want them to be. But Young finds this explanation disrespectful to women, as it dismisses the sensual and social pleasure they take in the clothes that they can afford. I certainly find it disrespectful to my mother-in-law, whose strong and experienced hand commanded a collection of clothing well marked by the defining characteristics of her personality.

Young specifically discusses the pleasure women take in touching clothing, bonding over a shared interest in clothing, and dressing to indulge the freedom of fantasy. I know my mother-in-law liked to indulge her sense of touch, as she once, with great ceremony, unwrapped some exquisite purses which she then invited me to handle. We never shared clothing, but we talked a shorthand about style and craft that created a circle of intimacy that excluded my husband. But I only found two dresses that allowed her to play at being someone else, or even at wearing someone else's style, a beaded floor-length gown (with matching shoes and memorabilia-

filled purse) and a fancy cotton peasant dress. I doubt my mother-in-law could allow herself to take such flights of fancy, for imagination reflects you back to yourself. When you play at being who you are not, you have the opportunity to step into the space between your character and your self to look back at yourself. But she did not want to be in that space. She was too definite to navigate through the ambiguity; too exacting to forgive what she might have found there; and too shrewd to place herself deliberately in a situation she could not control. Her artistic ability was expressed not through imaginative role play, but in concrete, functional ways: through home decorating, self-adornment, and tasteful social correspondence.

In a sense, then, my mother-in-law did engage in self-reflection. Her clothing, her purses, her definite tastes, her mastery of social rituals, all reflected her self. But I am disingenuously using the word "self-reflection" here. Self-reflection presents a thinker with multiple interpretations of the self, and the thinker must resolve, or find a way to live with, contradictions. What I am talking about is better described as "self-projection," the projection of a self outwards in order to create a kind of objectivity, a unitary evaluation of the self. One chooses objects which reflect an occasional, or perhaps a dominant, image of the self and surrounds oneself with those objects. The self of choice smiles back from every corner. My mother-in-law's tyrannical insistence that every object in her home sit in a precise place, free of even a grandchild's fingerprints, now begins to make sense. When her house was in order, then her inner life was in order.

When I inherited one-third of my mother-in-law's womanly effects (though she had four sons, she only had three daughters-in-law), I began to experience the strange power objects can have over personal identity. Suddenly I was dressing myself in clothes and jewelry

that had helped another woman grasp herself. I wondered what other people saw when they looked at me thus costumed. Did they see me? Or did they see her? I began to feel outsized by my own clothes. As I shrank, the messages I imagine the clothes sent filled my psyche with clouds. For example, when I went hiking I was alternately confident that people would see my mud-encrusted boots and know that I was a real hiker . . . and paralyzed by the fear that when they saw my wonderful wool hat, a gift from my husband, they would think I was an amateur with money to burn on showy gear. I began internally to narrate snippets of my days, in the hope that others would see scenes as I directed them. The direction was awful, of course, and my experiences shrank into dark frames seemingly crafted by immature artists. "There goes the competent mother . . ." the narrator would say, "there goes the not-too-bright pretender . . ."

Basically, I was disintegrating, bruised and confused by the events surrounding my mother-in-law's death, and I called upon the threads of her clothing to hold me together. Just after the death, I was angry with myself for not being as clearheaded and reserved as I sometimes want to be, and I was dazedly trying to sort out the insults hurled at me by relatives who never give a thought to being either clearheaded or reserved. I missed my mother-in-law terribly, for I was sure that, with her decisive and often oversimplified view of situations, she could have sorted things out for me. She would have told me that I was right, or at least swiftly and clearly why I was wrong. But she was no longer the arbiter of what happened in her overbearingly polite home, no longer the choreographer of her belongings. Her stern clarity was gone, and in its place loomed a crazy web of misunderstandings spun by her disintegrating survivors.

It wasn't just her steadiness that would have reassured me. It was also, and more so, her love. I did not

understand how I had earned her love, for I imagined I appeared oddly intellectual, overly strident, and not unquestioningly supportive enough of her son for her taste. But, suggested my husband, that was precisely what was so extraordinary about her love for me. I never had to suffer believing I had fallen, in her eyes, from precious child to disappointing adolescent. I never had to run from her out of fear that she could only love a child who reflected her self-image back to her, only to limp back, knowing my self-respect rested upon earning her respect. I simply stepped into her life and, after the initial distance between us that her commitment to formal etiquette required, into a shelter of acceptance she draped more and more snugly around my shoulders. When she died, her shelter dropped away, and I found myself exposed, unprotected, to a strange new world of self-interested judgments pronounced by her relatives. Suddenly under attack, or at least caught in the crossfire, I had no clue which projection of me was seen or could function in the unfamiliar family system that had been hers. I lost my confidence that the montage of thoughts, feelings, and actions that I call my personality had any center, any organizing principle. And I lost my confidence that, if there had ever been such a principle, it had been worthy of love.

What a contrast of selves! I, who had been so sure of my ability to move in and out of crisis, prepared for the necessary inner dialogue by years of studying philosophy, seemed to prove myself inadequate. My mother-in-law, on the other hand, snugly fortified, if not fossilized, by a ring of possessions, was able to assert her identity until the end. Her clarity returned when she was able to choreograph the scene of her death. Choosing to be disconnected from the life-supporting glucose intravenous unit, she said, "I can't stay here," and later, "I feel more peaceful now, just having made that decision." She talked of reuniting with her late husband, of the suit

and jewelry she wanted to be buried in, of the black dress with the silver beads on the shoulders she wanted me to inherit. She sweetly forgave all who called or came to see her, saying "I love you" liberally. Eighteen hours later, she passed away in her sleep.

Which model of the self deserves our respect? The multifaceted self, governed by reason, as described by Plato and Freud?[2] The vacant, infinitely pliable self shaped by social forces, as described by some sociologists and postmodern theorists?[3] Or the staunchly unitary self, rooted in a single organizing principle that transcends adaptation to any and all circumstances? All three models of the self deserve our respect, but none deserves to be relied upon unconditionally.

I believed myself to be modeled on the first type of self, but during those first few months of bereavement, the "postmodern" vision of the self marked the boundaries of my inner life. Such a self has no resources to do more than reflect or absorb the social messages around it. This is the self that critical theorists claim capitalists love, for it will buy any product it imagines will give it substance.[4] The more it tries to distinguish itself, the more it empties itself to fashion and platitude. In the end it is no self at all, just a reflection of the tastes and schemes of others. This is how I found myself after my mother-in-law's death. Emptied of confidence, away from familiar affirmations of my competence (it was summer and my comforting routine of professorship was temporarily suspended), I built my sense of self from the real or imagined responses of others. Not practiced at the use of property as a self-reflective device, I vainly tried to construct a self from shifting images of the meaning of various products. Though the postmodern method of becoming a personality crafts a flexible self, responsive to change, enabling persons to mold themselves to circumstances, it offers nothing when all supports crash. Nothing was left for me but hastily

adopted, crudely copied caricatures of the imagined tastes of others. I longed for the certainty my mother-in-law seemed to have had, the certainty I had derided as philosophically immature.

My mother-in-law's sense of self was an incarnation of what philosophers call the early "modern" philosophical vision.[5] Such a self has a core, an awareness of identity that accompanies all perceptions. In abstract philosophical writing, that core is described as if it has no particular social, ethical, or aesthetic content; it is simply an awareness that all experience is anchored to the same remembering, organizing consciousness. But in real life, the core of each person's self does appear to have a particular character. That character remembers, perceives, and organizes selectively as it forms a life. Such an anchored method for developing a personality has its strengths as well as its vulnerabilities. Yes, it gives one the strength to know who they are, and the incentive to build that knowledge into the material world around them. And a carefully chosen projection of self into the environment can serve as a reminder of who a person means to be when stray emotions threaten their principles. But this projection, carefully ordered over years of shallow ups and downs, can deteriorate into caricature if it tenaciously maintains its form as life explodes into disorder. And it was the caricature of her earlier self my mother-in-law often became in the years preceding her death that I had criticized.

Neither the modern nor the postmodern method, it seems, creates a self impervious to shock. Anyone, no matter how they have crafted their lives, can deteriorate into caricature. And the reflective self, in which the sobering power of reason continuously asserts itself, offers no guarantees of safety either—at least it offered none to me. In life, we ride the crests of believing "I am something," and the troughs of believing "I am nothing." Self-reflection is best understood as an openness to

both extremes of the ride. As I defined it earlier, self-reflection presents a thinker with multiple interpretations of the self, and provides the thinker with the tools to resolve, or find a way to live with, contradictions. Self-reflection responds to, doesn't ward off, a crisis of the self.

And yet, isn't this what my mother-in-law did, respond to a crisis of the self? Gracefully and graciously, in keeping with the permanent organizing principle she so skillfully crafted for herself, she adapted to the certainty of death. Just as values cannot be judged out of the context of the life which animates them, so a mode of constructing the self must be seen as it undulates and stretches to fit the challenges of life. Beneath all the generalizations and characterizations lies the mysterious and unique actor who bestows a sense upon the drama unfolding around her. It is this unique self that I miss when I recall my mother-in-law, this self who molded a life out of categories so alien to mine, this wise and beautiful woman whom I never would have called wise had I not been willing to put aside my theories to attend to life, hers and mine.

Notes

1. Iris Marion Young, "Women Recovering Our Clothes," in *Throwing Like a Girl and Other Essays in Feminist Philosophy and Social Theory* (Bloomington: Indiana University Press, 1990), 177–88.

2. See excerpts from the writings of Plato and Freud in Leslie Stevenson, ed., *The Study of Human Nature* (New York: Oxford, 1981).

3. See, for example, Madan Sarup, *Post-Structuralism and Postmodernism*, 2d ed. (Athens, Ga.: University of Georgia Press, 1993), 12–14.

4. See, for example, Susan Bordo, "'Material Girl': The Effacements of Post Modern Culture," in *Free Spirits: Feminist Philosophers on Culture*, ed. Kate Mehuron and Gary Percesepe (Englewood Cliffs, N.J.: Prentice Hall, 1995), 66–81.

5. See especially the "Second Meditation" in René Descartes, *Meditations on First Philosophy,* trans. Donald A. Cress (Indianapolis: Hackett, 1979); and the "Transcendental Deduction" in Immanuel Kant, *Critique of Pure Reason,* trans. Norman Kemp Smith (New York: St. Martin's Press, 1959).

My Mother, the Mirror:
Conflict and Self-Knowledge

My mother's approach to the problem of personal identity is the opposite of my mother-in law's. My mother-in-law sought an ordered self, embodied in the material objects around her. My mother seeks neither order nor permanence. Instead, she advocates keeping the self fluid, never allowing it to rest too comfortably within a single identity. I like to think she puts into practice her own unique interpretation of the views of phenomenological philosopher Gabriel Marcel.

According to Marcel, no single perspective on a person can reveal completely their realities and possibilities.[1] This mysterious quality of persons can set the agenda for self-knowledge, defining it as a search for and synthesis of perspectives on one's self. However, as my mother knows, the pursuit of self-knowledge can be sabotaged by a dominant self-image that aggressively filters experience. Sometimes, therefore, a seeker of self-knowledge needs a little help from outside events. But as this help often comes in disguise, the challenge is not to overlook it.

This essay is a diagnosis of and prescription for such lost opportunities. Martin Heidegger's definition of the work of art is the theoretical lens through which I analyze the potential of interpersonal conflict to open new perspectives on ourselves. By exhausting the resources of a reigning perspective on the self, interpersonal conflict can motivate us to draw upon possibilities which have not yet been charted. Below I shall present Heidegger's definition of art as that which calls upon us to recreate the world, speak by analogy of interpersonal conflicts which call upon us to recreate our personal worlds, and comment on the image of a world in Western epistemology.

A Definition of Art

I have an office at the university. It has a desk, bookshelves, a filing cabinet, a table, carpeting. It reeks of utilitarianism, of wholesale office supply, of the bottom of the line in a state bureaucracy. I also have an office at home. It has a desk, bookshelves, filing cabinets, a table, a rug. It exudes warmth, wealth, dignity, and a stately regard for the history of ideas. When I am at the university, I pay no attention to my office. I don't admire it, nor does it disgust me. I simply work in it. It is, as Heidegger would say, a piece of "equipment." I focus on those aspects of it which enable me to do my work. As long as I have access to the desk, phone, and file cabinet, I can work amid piles of unfiled memos, unread mail, and unclaimed student papers from semesters past. But I cannot work that way at home. My home office commands my attention. Each time I enter it (365 days a year, ten times a day?) I am reminded of the first time that Mr. Moore of Moore Cabinets in Huntersville, North Carolina looked at the empty room with the eyes of forty-years experience and conceived a library filled with tall shelves, hidden file cabinets, and elegant flourishes along the ceiling. Daily I marvel at Mr. Moore's ability to transform a formal dining room, with its

ornate chandelier and its fading ecru walls, into a rich baritone of a room that vibrates with love for scholarly tradition. Mr. Moore has taken a room that once meant one thing—respect for the social conventions of entertaining guests, perhaps—and made it mean something else. He has taken wood and metal, polyurethane and glue—neutral, natural things—and made *meanings* with them. Working with things whose nature he could not change, he created an object whose nature was entirely under his control, an object whose nature expressed his.

For Heidegger, the fact that my home office calls my attention to the contrast between the untameable and the tamed defines my home office as a work of art. He says that a work of art thrusts our attention towards the eternal conflict between the historical human "world" of meanings in which we live and the "earth" which we cannot penetrate, change, or understand. The conflict cannot be resolved, but a work of art creates an "Open[ing]" between the terms of the conflict. When Heidegger speaks of the "world" he means what phenomenological philosophers mean: the environment we create for ourselves through our beliefs. When Heidegger speaks of the "earth," he refers to the physical environment in which we live. The eternal conflict between "world" and "earth" can be understood as a recurring conflict between the way we think things are and the way things are. Art creates an "opening" by inviting us to recreate the world in response to the conflict. On this definition, what gets called "art" is not restricted by conceptions of performances, exhibits, or disciplines.[2] I shall speak below of persons who function as works of art, who challenge us to recreate our worlds.

My Mother the Mirror: A Work of Art

Recreating a "world" is no mean feat, as it involves changing the very ways we see ourselves and other people. A world is founded on a self-concept. "I am a———"

is the first premise in a network of syllogisms whose conclusions are our choices in life. "I am an intellectual," "I am a caretaker," "I am a mother," lead to very different choices of friends, leisure activities, reading materials. These different founding premises lead to different attitudes towards people, different ways of weaving them into our worlds. And their responses become premises which circle back to conclude the founding premise, enabling us to affirm again and again, "I am an intellectual," "I am a caretaker," "I am a mother."

When we try to fold people into our worlds we treat them as equipment, in Heidegger's sense, and they fade into the background of the task at hand. The task at hand is to actualize and affirm our self-concept, that is, to do our work in the world. We notice those aspects of people which enable us to do our work. For example, if we are caretakers, then we notice how each person needs to be taken care of. We might not notice their dignity, their refusal of our care. Or we might not notice their meanness, that their behavior is a calculated physical or psychological assault on us. Much of the time we are able to carry on our work in the face of these difficulties, using them as an opportunity to remind ourselves that our work is as arduous as it is worthwhile. Sometimes, however, we are confronted by persons whose refusal to be seen from the perspective of our work makes it impossible for us to work. Those persons leave us with three options: to cut off entirely our relationship with them, to try to force them to see themselves as we wish them to, or to revise the founding premise which causes the conflict. Viewing a person as a work of art results in the third option. We recognize that the person turns our attention towards the gap between our world, i.e., our self-concept and its implications, and the earth, i.e., our real nature, apart from any self-concept. Our real

nature is, as Marcel implies, a mystery. But a self-concept offers a perspective from which to understand ourselves and begin to act. And, as Heidegger says, we cannot penetrate, change, or understand the earth, but we can confront it as the first step in creating a new world.

Let me explicate by example. My brother's girlfriend's founding premise, "I am a caretaker," leads her to noble work, unquestionable in its value. She would like to extend her activities to take care of my eighty-one-year-old aunt. To do that, she needs my mother's cooperation. But my mother actively resists being used as a tool for carrying out anyone's work, for building anyone's world, for maintaining anyone's founding premise. My mother's founding premise is "I am a mirror." Camouflaging herself by chattering continuously, she carefully observes other people to find the ways in which they do not meet their own expectations, the times when their founding premises cannot be deduced logically from events. And she calls their attention to these times. In other words, she finds and pushes people's buttons! The rare flexible persons who do not identify their full natures with their founding premises can recognize what she is doing and reluctantly reflect on the truth she has revealed. But other people, unwilling to look at the weak links in their worlds, take her lighthearted jibes as simpleminded jokes and her angry declarations as irrational babblings.

When my brother's girlfriend pressed my mother to find a senior citizens' residence for my aunt, my mother shouted, "I don't want to help! I'm selfish! I don't want to give up my tennis!" My brother's girlfriend was shocked: how could my mother so boldly flaunt her own moral failures? "Your mother reacted completely irrationally," my brother's girlfriend told me. And in the context of the world of the caretaker, my mother's response was indeed "irrational," following

no available logical path to or from the founding premise. My mother was attacking the founding premise, shouting in code, "Caretaking is not an absolute value! It does not supersede everything else in *my* world!" But my brother's girlfriend did not attend to my mother.

My brother's girlfriend failed to notice that my mother had *deliberately* shouted a shocking response. One might say that she failed to attend to my mother's demonstration of the gap between world and earth. Or that she did not recognize that my mother was offering her an opportunity to reexamine her founding premise. My mother's refusal to cooperate was an invitation to my brother's girlfriend to call upon personal resources which fall outside of her world, and which can be used to deconstruct and reconstruct worlds. My mother's incomprehensibility offered my brother's girlfriend an opportunity to find herself in a larger sphere of possibilities. But my brother's girlfriend did not, at that time, choose to subordinate her goal of caretaking to the pursuit of self-knowledge.

My mother, of course, is an extreme case. It is easy to see how she is like Heidegger's art that bursts between "world" and "earth." Her very presence, if you allow it to, creates new meanings. And *you* are her medium. She is a mirror; she reflects you back to yourself in inverted form. One day, years ago, I wandered into the junk room in her semi-finished basement. I found a chalkboard on which my mother had drawn a silly-looking stick figure and written, "This is you in the mirror. What mirror?" When I confronted her with the chalkboard, she giggled uncomfortably, shrugged and explained, "Dave borrowed a mirror from me to hang down here and he never hung it." Close call for her! I'd almost articulated her work in the world, which depends upon secrecy for its efficacy.

The Doctor-Patient Relationship:
Ignoring Art

But other persons, ordinary persons, even powerless persons, who have no intention of forcing others to face themselves can nonetheless have that effect. In particular, I am thinking of the physician-patient relationship.

Tales of a recent experience: We are at the Mayo clinic, a world-class medical research institute where patients with incurable diseases come hoping to be told they have the right combination of symptoms to qualify for clinical trials of some new drug or surgical procedure. The physicians are at the cutting edge of technology, and the patients are at the cutting edge of hope. It's a strange intersection—the patients seeking salve for their decaying souls, the physicians trying to extract the bodies from those souls.

The physicians are not, strictly speaking, unethical. They define the research studies, present their rationales, spell out both physicians' and patients' responsibilities, freely admit "I don't know" when they don't, seek consultation from other physicians when they need it, refrain from making false promises, and clearly answer all of the patient's questions. But when the patient brings up matters of the soul—her or his fraying emotions or dissolving faith, the physician briefly acknowledges the patient's pain with an inflection suggesting the physician is reading from a dictionary. The physician then steers the conversation quickly back to matters of the body—the patient's symptoms and their fit with the available medical procedures.

The physician's behavior is, of course, an expression of some obvious truths. Researchers at this institute are hired to develop new bodily cures and they see themselves accordingly. Daily they are deluged with new hopefuls as their patients, and they could not save humanity as they have been charged to do if they took

time to counsel each patient. I am not being facetious—
the physicians have important work in the world to do,
and they genuinely want to do it. But what other, less
obvious truths underlie this behavior? Is the physician
afraid to hear about and see the patients' emotions? If
so, why? Is the physician afraid of feeling the despair,
the fear, the frustration, the hope of each and every
patient, afraid that the compounded weight of all those
feelings would wear the physician daily to a frazzle?
That all of the physician's nonwork time would be spent
healing the physician's own soul? I am sure that these
fears lick at the edges of a physician's composure. How-
ever, I do not think these are the only fears that distance
the physician from the patient.

The research physician's work in the world focuses
exclusively on the human body. To attend as well to the
human soul would remind the physician that humans
are not merely bodies. That reminder would call into
question the validity of the physician's work in the
world. If people are not primarily or exclusively bodies,
then how well is the physician serving humanity by
studying the body alone? The physician's fear, I think, is
not only a fear of confronting or facing the patient, but
a fear of confronting the physician's own self.

Western Epistemology: Images of 'World' and 'Earth'

As I try to insert my imagination into the physician's
psyche, I picture myself sitting on a swiveling throne in
the center of a frosted glass bubble. Within the bubble, I
can see myself and my patients clearly. I can see shapes
moving about outside the bubble, but as they rarely
come close, I do not attend to them. But suddenly a
shape rushes towards the glass and its details become
clear. It is a patient's face, pressed up against the glass,

grotesquely distorted. The patient bangs on the glass insistently, pathetically. I am afraid that if I give the patient any encouragement, she will bang more loudly, and, with one sharp fist, shatter my bubble. I swivel away, turning my back.

This image of the thinking subject at the center of a circle or sphere representing a known world, with an unknown earth outside the circumference, is a recurring theme in the Great Books of Western Philosophy. For example, in Plato's allegory of the cave, prisoners chained to a cave wall see only shadows because of the odd location of the cave's only light source. Prisoners must free themselves before they can climb outside to see the sun illuminating the world as it really is.[3] In Immanuel Kant's epistemology, what a person can know is circumscribed by the human conceptual and perceptual apparatus. Outside the sphere of knowable phenomena lie the unknowable "noumena," things in themselves. But for Kant, no light is bright enough to reveal to us the noumena.[4]

The later epistemology of Heidegger shares Plato's optimism. For Heidegger, our usual automatic, unreflective attitude towards living settles us comfortably in a known region of objects and persons. Outside this region is "that which regions," the possibilities from which the knowledge that becomes crystallized in and through the habits of daily living is drawn. That which regions calls to us. To hear its call, we have only to think, i.e., to wander off the well-paved highways of the mind and dwell in what we discover.[5]

But, as I have been shouting in this essay, this type of thinking is not easy. In this essay, I have applied epistemology's image of the sphere to self-knowledge. Inside the sphere, the self we know spreads out, making itself comfortable in familiar intellectual and emotional surroundings. Beyond the sphere dance other possibilities for who we could be, what we could think, feel, and do.

For Marcel, for Plato, for Heidegger, and for me, the true self lies in those possibilities. But that self is mysterious, for while unrealized possibilities may draw a life forward in hope or backwards in regret, unrealized possibilities are not the tangible currency of everyday life. We can only think of the true self as a well, from which we regularly draw possibilities that illuminate and rehabilitate our lives. When others come knocking on the sphere of our known selves, when their knocking threatens to shatter and crumble the known self, we should recognize them as emissaries from "that which regions" and risk confronting the mystery of the true self.

Notes

1. Gabriel Marcel, *The Mystery of Being* (Chicago: Regnery, 1950).
2. Martin Heidegger, "The Origin of the Work of Art," in *Poetry, Language, Thought,* trans. Albert Hofstadter (San Francisco: Harper and Row, 1971).
3. Plato, *Republic,* in *Plato: Collected Dialogues,* ed. Edith Hamilton and Huntington Cairns (Princeton: Princeton University Press, 1973), 575–844.
4. Immanuel Kant, *Critique of Pure Reason,* trans. Norman Kemp Smith (New York: St. Martin's Press, 1959).
5. Martin Heidegger, *Discourse on Thinking* (New York: Harper and Row, 1969).

My Father the Philosopher:

Body and Mind, Hopefully Intertwined

In this philosophical tribute to my father, I take up philosophy's traditional discussion of the gulf between the human psyche and the human body. The two so often seem to work at cross purposes that articulating a split between them seems inevitable. Yet, as I argue in this essay, the human psyche, that is, mind and spirit, depends for its ethical and intellectual development on the human body. I tell, in tandem, stories of my father's and my illnesses, emphasizing at first our desire to overcome the demands of the body and, finally, although paradoxically, our engagement with the body as the motivating force behind this desire.

A Passion for Ideas in the Mind

I invite my father into our dream . . .
Even my father will dance in our house.
My father, the big man,
the bull headed superman
who leers and sneers and shows his teeth
moves slowly, the weight of his body
knocks down buildings.

They blow apart, shards fly slowly
through clouds of pebbles and dust.

Even my father, the big man
will become a little man dancing.
His legs will shrivel, hips grow wide,
spindly legs will hop and shake.
His arms fly back,
he giggles in short gasps,
throws back his head and laughs,
"I'm laughing! I'm dancing!"

Even my father will dance in our house.
His own grand childhood awaits.

So I wrote when I was twenty-two, falsely imagining that my father would one day embrace the young man I then loved. My father was sixty-six at the time; he is now eighty-one. The big man, handsome, athletic, strong, pugilistic, has now become a little man—not in spirit, as the poem suggests, but in body; and not joyfully, but reluctantly, dragging in resistance as best he can. Blind in one eye, shuffling a bit as he walks, he goes to work as a lawyer every day. Each morning he wakes at 6:00 A.M., dresses in his suit, and waits for his son to drive him to the office. By his own admission, he gets nothing done. Nonetheless, the ritual continues, weekday after weekday.

"Slow down," our family advises him. "Accept that aging affects the body. Retire, sell, hire a successor . . . don't knock yourself out."

But alone in my study, free to distance myself from the obligatory platitudes of caring, I am free to understand my father. Here it is, eleven P.M. Between my job, my household, and my two young children, I haven't had a good night's sleep in over a year. I'm recovering from a respiratory infection. Having finally acknowledged the defeat of my body's own natural healing powers for the first time in twenty-five years, I've been

greedily, ritually gulping down antibiotic capsules. Tonight, my cough is quiet but my lungs are weary. It hurts to breathe in, into my tired throat and burning upper rib cage. This pain connects with a mild upper back injury, probably caused by hoisting and hauling children, exacerbated by hoisting a backpack, by doing ballet improperly. Swollen, hot, tender when touched, my upper back burns with each breath. And I'm so tired, I haven't eaten well today, have had caffeine which makes me crazy . . .

But: I have goals, things I want to do.

Creative expressions . . . writing . . . the fun of taking a sprout and unfolding it leaf by leaf . . . the pleasure of searching for words to say what I know is there and then riding those words on to the next unknown ones, shaping them in turn . . . riding the current to the next general direction and then, once having found the direction, shaping, choosing each word carefully. Riding clouds in my psyche, discovering what is on each new one . . . the words, the language only the visible markers of ideas, psychic truths, half-formed energies.

My father knows these pleasures, I am sure. He loves to write.

And achievements, too . . . standards in each area for what I want to accomplish, hinged not on reality, not on the available time and resources, but by the inexorable crazy push of ideas linking with ideas . . . things that ought to be because they can be, not because I can do them . . . and the soaring feeling of a new unity that accompanies the unexpected bisociation of two disparate lines of thought.[1] This movement of ideas transcends the body, ignores the limitations of material reality, bends that reality to its will, masters it, pushing through incoherent exhaustion.

My father knows this experience.

This experience is characterized only in a superficial way as professional ambition. Its standards aren't set by the profession, though the demands and conventions of

the profession weave into, braid into, touch base with, form one strand of, are a touch point for, intersect, bounce together with the blind logic of manic creativity. Professional standards simply give me ideas for things to have ideas about. This is my life, this is what drives me, I spiral out of control sometimes. Thank goodness for dishes and laundry—though some creativity experts say those activities stimulate the incubation of new ideas, by giving the mind time to process its inputs before spitting out the shiny new, the compelling.[2]

My dad knows all this, though he may not be a creative genius, or driven as I am. But he still has the next idea—a case to win, a way of providing for his grandchildren—and the demands of the body cannot be allowed to interfere. It doesn't matter if on some days he cannot think clearly enough to envision a case strategy; it doesn't matter if he owes more than he owns. Ideas have their own logic and this logic must be followed.

It would seem that my father lives a life of the mind. In Plato's *Phaedo,* the character of Socrates seems to affirm that life. The purpose of philosophy, the supreme art of living, is to prepare to die by cultivating indifference to the body. The goal is to separate psyche from body, and never let the prospect of physical death fool you into believing in the death of the psyche. The successful philosopher, therefore, does not fear death.[3]

My father, it would seem, has succeeded in separating soul from body. Captivated by the pressing claim of ideas, he has ignored his body's demands. Yet he is not a successful philosopher by Socrates' standards, as he admits freely that he fears death. Socrates thought the fear of death results from a person's love for the body. My father's story, however, inverts Socrates' view. My father's fear of death is born of his love for the mind. For my father, accepting bodily decay would mean allowing physical abilities to set limits to the mind. Limiting the mind would mean stifling and slowing a rushing cascade of ideas. Death of the cascade of ideas

would be death of the soul. In my father's experience, the life of the mind has not been a preparation for death at all. Instead, it has been a jubilant affirmation of life.

Perhaps my father fails to qualify as a philosopher on Socrates' criteria because he does not live the life of the mind as Plato conceives of it. My father's ideas are often plans, meant to be applied and actualized, to mold the world in their image. Perhaps Plato speaks of pure ideas, articulated with an economy of words, examined rationally through dialogue and dialectic. But this characterization of pure ideas does not distinguish it adequately from the ideas that hold my father in thrall. Supposedly "pure" ideas still need to be put into words, given concrete shape in metaphors, spoken, written, passed between friends and colleagues so that in the creation of dialectic some product comes into the world. The distinction between pure and applied thought dissolves when I try to think about it. I find no pure ideas free from the delight, or sometimes the angst, of creation, of giving them concrete form. My father's love of the mind is not really possible without a love for the body, or at least a love for the tangible world. Hence, his love for the mind appearing as an affirmation of life.

I cannot accept Socrates' sharp distinction between psyche and body if it celebrates the striving for a purely intellectual philosophy. A philosophy that has no relationship with the world of action, the world of bodies tainted by the problems of daily living, would be disingenuous, inaccurate, useless, and even immoral. It would be disingenuous because it would deny its own origins. Surely, for example, philosophers speak of justice, as Plato did in his masterpiece the *Republic*, because they seek to remedy particular injustices. Plato's own attempts at creating an actual philosopher-king might be seen to imply this motivation. But were philosophical inquiries into justice to lose the shape of the questions that motivated them, these inquiries could only answer distorted, oddly abstract questions, such as

those Platonic scholars claim motivated Plato, for example, "What is the relationship between the Form of Justice and other Forms?" These questions, considered only at an abstract level, could not produce useful answers, that is, answers that have anything to do with the inadequacy of our institutional attempts at creating justice and our consequent needs for guiding ideals embodied in abstract Forms. Finally, I would find a lifelong devotion to such questions immoral, as it serves the world quite poorly for a great intellect to waste its time spinning elegant abstractions which do not make the world, nor the lives of anyone within it, better.

Fortunately, my father, gifted intellectually as he is, has not wasted his time with such inquiries. In his limited spheres as (among others) father, grandfather, synagogue board member, camp counselor, and honest lawyer seeking financial compensation for victims of injury, he has applied his intellect to puzzling out schemes to help others, and to untangling the paradoxes of hope and cynicism he encounters in his efforts.

Compassion for the Suffering of the Body

My back "injury" has turned out to be the early stages of the nerve pain associated with shingles. I have a painkiller but in between dosages, and with the pains it can't silence, I wander aimlessly from room to room, unable to focus. Perhaps if I walk far enough, fast enough, I'll leave the pain behind, it'll slide right off my back unable to catch up, like a coat or cape hanging in the air behind me. I have an antiviral medication, but it suppresses my appetite, brings on nausea, and fogs my mind, making clarity of purpose impossible.

I call my parents for sympathy and learn that my dad is in far worse pain than I am. One week earlier, as he, his older sister, and my mother were leaving from a

four-day visit to my house, his sister tripped and fell at the entrance to the airplane. He tripped and fell on top of her. Her foot is painfully swollen, and she has been confined to a room at my parents' home for a week. My father is feeling intense pain in his lower abdomen, and is wondering if his pelvis is broken. No one has taken either of them to a doctor or nurse, though a week has passed since their fall.

I call them every day, sometimes twice, and think of them every few minutes. My own pain, now diagnosed, now being treated with drugs, and now expected to end within several weeks, seems minor somehow. And yet it is only this minor pain that allows me to understand how great their pain must be. It is my pain that reminds me of their needs, of their immobility and exhaustion, thickened over by their confusion and uncertainty. In league with my brother, I arrange for my mother, in constant pain from arthritis herself, to take each to an appropriate clinic. We learn that my aunt is recovering and my father has a kidney stone.

I feel guilty about taking the painkiller my nurse has prescribed. It seems immoral, so I take it at irregular intervals and only when the pain is nearly unbearable. Standing in the shower, pain temporarily soothed by the massage of hot water, I try to understand the source of my uneasy conscience. Painkillers are a luxury, I reason. There might be some time, in war, famine, after nuclear holocaust, when painkillers will not be available. I must learn to live with pain, or at least know that I am able to, in case I am caught in such a time. Finally understanding my objection to the medication, I tell my husband. He disagrees with my labeling of painkillers as a luxury. On the contrary, he says, pain medication is a necessity, if we are to function. His view is consistent with his belief that access to affordable health care is a fundamental human right. And now I see that my perspective has been too selfish. Perhaps, for me, there will come a time when I am in pain and do not have access

to pharmaceutical relief. But many other people are caught in that time right now. How do they live with pain? How can I help them? Where can I contribute money, to whom can I minister? My own pain has developed my compassion, first for my own father, and next for unnamed, but not so alien beings, their composite faces constructed from my memories of crowded sidewalks and video clips of refugee camps.

Suffering itself may be morally neutral, a mere fact in a mechanical universe of cause and effect that happens to include among its contents sentient beings. Yet physical suffering provides those sentient beings with opportunities for moral improvement. In the third section of the science-fiction novel *A Canticle For Leibowitz,* author Walter Miller evokes a world melting into nothing but suffering. People horribly damaged by nuclear bombs can make their way to mercy camps and request euthanasia. But Miller's protagonist, a sophisticated modern-day monk, tries to throw himself between radiation victims and their release from suffering. When a doctor supportive of euthanasia mentions having a soul, the monk responds angrily, "You don't *have* a soul, Doctor. You *are* a soul. You *have* a body, temporarily."⁴ Yet, oddly, the monk argues that the body, far from worthy of being forgotten by the soul, serves it. Trying to dissuade a young mother from euthanizing her perpetually crying, badly burned, terminally injured infant, he argues that suffering improves the soul. Of course, the reader is given a difficult case to digest: it is not clear how the soul of an infant, lacking even a child's self-consciousness, will be improved by suffering. But the monk's words echo in my mind, perhaps only as a desperate attempt on my part to give meaning to my own ridiculous, inconvenient illness. With only a small analogical leap from my own condition to the conditions of others, my own suffering has the potential to develop my empathy, and, from that, my compassion. Empathy brings what I imagine to be the experiences of others

into analogy with my own experience. And when my own experience is of pain begging to be relieved, empathy for others becomes compassion, the desire to do something about their suffering.

Perhaps Plato misses the importance of the body to an ethical life because he has a different conception of what it means to be ethical. Caring is not central to his definition; rational consistency and equanimity are. Intellectual detachment from life facilitates the deliberation needed in order to act with elegance, consistency, and economy. But in a time when ethical behavior is understood as caring behavior, or, even, in other words, as principled behavior towards others, bodily engagement might be seen as essential to ethical understanding or ability, as the first step towards compassion.

Conclusion: Engagement With Traditional Wisdom

In *How to Know God: The Yoga Aphorisms of Patanjali,* Christopher Isherwood writes, "our pity will teach us understanding and, hence, freedom."[5] In the yogic tradition, he is speaking of freedom from the ego's over-identification with its own experiences. What Isherwood calls "pity," and what I have called "empathy leading to compassion," can move us out of immersion in our own suffering to awareness of our ability to ease the suffering of others. Yes, this pity helps to detach us from our own bodily experiences, which is the goal of Socrates' successful philosopher. But this detachment, this freedom, is only made possible by a careful listening to, and a creative interpretation of, one's own bodily experiences. Perhaps, as philosopher Ludwig Wittgenstein says, "We must kick down the ladder after we have climbed it." Nonetheless, we must not diminish the importance of the ladder.

The solemn Jewish holiday of Yom Kippur (Day of Atonement) is a day of fasting, twenty-six hours long. We pray all day, reminding ourselves of our ethical responsibilities and our shortcomings in fulfilling them. In an attempt to link our own deprivation to the development of compassion, our prayerbook reminds us, "This is how it feels to be hungry." This year I not only know how it feels to be hungry, but also how it feels to be hungry and in pain. Never again will I be swayed by those who ask, perhaps even in good faith, "Why don't those hungry people just get up off their duffs and get a job?" Have they never been hungry? I wonder. Do they not know how hunger takes away our focus, concentration, energy, will, ability to get anything done? Or have they just not learned to listen to their own bodies, to connect that deeply felt knowledge with the more superficial information they receive about the lives of others? I marvel at the wisdom of our tradition in making our most solemn day of ethical awareness revolve around a bodily discipline. Again, I affirm the connections I have articulated in my secular life as a philosopher: between experience abstracted into theories and experience as lived, and between the active mind's joyful or painful leaps and the incarnation or application of those leaps in practice.

Finally, I find myself profoundly moved by the Psalmist's request of God, also part of the Yom Kippur liturgy, to grant us the satisfaction of bodily, worldly creation:

> Let the favor of the Lord our God be upon us,
> and establish thou the work of our hands upon us,
> yea, the work of our hands establish thou it. (Psalm 90)[6]

Notes

1. The term "bisociation" is drawn from Arthur Koestler, *The Act of Creation* (New York: Macmillan), 1964.

2. See G. Wallas, *The Art of Thought* (New York: Harcourt Brace), 1926.

3. Plato, *Phaedo,* in *Plato: Collected Dialogues,* ed. Edith Hamilton and Huntington Cairns (Princeton: Princeton University Press, 1973).

4. Walter M. Miller, *A Canticle for Leibowitz* (New York: Bantam, 1959), 272.

5. Swami Prabhavananda and Christopher Isherwood, *How to Know God: The Yoga Aphorisms of Patanjali* (Hollywood, Calif.: Vedanta, 1953), 23.

6. This translation appears in Leslie Stevenson, ed., *The Study of Human Nature* (New York: Oxford, 1981), 10.

Mothering

Mothering and Pacifism:
Surprises and Suspicions

A View from inside Mothering

June 1994: At the time of this writing, I have only been a mother for sixteen months (plus an expectant mother for nine), but already my metaphysical, ethical, and epistemological experiences are changing. A single human life now seems infinitely valuable. And the wounding of a single person seems a tear in a fragile, infinitely extended network.

Giving birth brought my first epiphany, sudden, raw, and radical. Less than twenty-four hours after giving birth, I lay in bed with my newborn, bathed in afternoon sunlight and exhausted euphoria, and imagined the human race passing by on the sidewalk in front of my house. My imagination drew on the diagrams that show the evolution of hominids through the prehistoric eras, or the relative proportions of body parts through the human life cycle, with their drawings of the human body at various stages of uprightness, ascending and descending in height. I saw generations of humanity pass by simultaneously: children accompanied by the teenagers they become, the adults they mature into, the

elders they become, and, again, the children they grand-parent, all together in a steps and stairs parade. I saw that all humanity participates in the same parade, enmeshed in connections that are so trivial as to be meaningless to the observer but so basic as to set the very categories of experience for the participants. Now, when I look at a person, I see them as a freeze frame in the parade of humanity; my mind's eye adds a family. I have come to realize that everybody is connected to others; at the very least, everyone is somebody's child.

For every person, there at least exists a mother, who, if she had the luxury or difficulty of caring for them, learned from them about the fragility of life, the pain of hope, the possibility of a new relationship to the unknowns of life and the creature we imagine controls them, God. I, who was brought up to believe, and do believe, that God helps those who help themselves, now know a new sense of helplessness which, at its best moments, is transformed into wonder. Two weeks after giving birth I wrote the following short essay, which I called "When you wish upon a star."

Sometimes when I hold my two-week-old daughter against me after nursing her, we listen to the tape of lullaby songs my husband made for her. The nursery is semi-dark, we are semi-naked, I feel her skin against mine as she begins to doze, her face relaxing, her head drooping. Quietly, I sing along with the tape, barely whispering in her ear.

"If your heart is in your dreams / no request is too extreme / anything your heart desires / will come to you. . . . When you wish upon a star / your dreams come true."[1]

My eyes tear up and I sob quietly, being careful not to wake her or shake her.

Why do I cry? Perhaps because she is so precious, even though she's hardly anything or anyone yet. The

mystery of it colors and scents my days, transforming the fragmented tedium of infant care chores into a peaceful routine.

But why does the song "When you wish upon a star" make me cry? The lyrics seem like one of those sweet lies we devise for children. Yet it seems now that my dreams have come true. I have my husband, my job, health, happiness, and now Hillary. Perhaps I cry because I don't know whether or not what the song says is true. Was my heart in my dreams? Does that mean I worked hard to make them come true? Does hard work make a difference? Or is it only a sweet lie that wishing makes it so?

And I cry because I don't know what I dare wish for Hillary. Even wishing that she grow up healthy over the next two years, that her development unfold normally, seems to be asking too much. What if it didn't happen? Of course, if it didn't happen, then the next wish would be that she perform to her capacity, that she be happy, and that my husband and I cope peacefully. Even that would be okay.

But as I think, "Even that would be okay," my eyes fill with tears again, my body shakes with the embryo of a sob, my nose runs. I just cannot fathom the future—it is deep, deeper, deepest. I get a tiny vision of what it might look like for the three of us to be happy together and it hurts too much. I cry at my good fortune and at the fear of losing it, because all is fortuitous and fragile. Why is it so scary to hope?

Meanwhile, Hillary winks and blinks, cracks a smile, snorts, sighs, and snuggles against me. She is still learning how to fall asleep.

Am I crying tears of joy?

Sixteen months later, I truly do not know what kind of tears I was crying. Caring for a child has brought another round of revelation, this time dawning upon me

more gradually. The intense joys of mothering seem to be gifts of grace. They appear without warning on my daughter's person: her mischievous kiss, designed to divert me from disciplining her; her generous sharing of her toys with a (surprisingly, to her) disinterested cat; her systematic attempt to learn the difference between a cookie and a cracker. But my sense of helplessness in the face of the universe is balanced by a new self-mastery. Or perhaps it is the opposite of self-mastery, more like a letting go of self. Sara Ruddick writes that "A single, typical day [of mothering] can encompass fury, infatuation, boredom, and simple dislike."[2] Yet in the face of those feelings, there is a job to be done, the job of loving the object of those feelings. Is it possible to love someone who angers you, bores you, and makes you dislike them? Yes, if love becomes a practice, rather than a feeling. Yes, if love becomes what Kant calls a "duty" rather than an "inclination."[3] This does not mean I do not enjoy loving: sometimes I do, sometimes I do not, but always when I assess the meaning of my life against the standard of solidity, I feel or think that practicing love has created something in the world equal to what it took from me, though leaving me exhausted. But how does one practice love in the face of unpleasant feelings? I have learned to do so by developing a new relation to my feelings: they have become the background muzak to a day's work. My own desires are irrelevant to successful completion of the aims of the work. And, oddly, continuing the work in the face of feelings of frustration (as my self-mastery is not perfect) gives me a new sense of competence.

Finally it is easy for me to see how so many mothers have taken a stand for pacifism in the name of mothering.[4] The new metaphysical sensibilities I have described can motivate a mother to care about peace. If everyone is connected, the wounding of one person touches off a network of suffering. If everyone is

someone's child, every death rips an irreparable wound in a parent's heart and every enemy demon has a great deal in common with you. If control over the sources of our joys is just past the horizon of our reach, then avarice and greed seem like wasteful exercises. And if love can be practiced even when it contradicts our feelings, then it is possible to love in the face of propaganda to the contrary, and it is possible to love even those who threaten violence. The moral imperatives of mothering are so strong, that if they could be linked to a peace politics, surely we would have an example of William James's "moral equivalent of war."[5]

It is hard for me to believe that preservative love, fostering growth, and social training, which are the basic aims of mothering as identified by Ruddick,[6] are anything but universal aims. And because the lessons that I am learning from trying to achieve those aims are so intense, it is hard to believe that those lessons are not universal. Perhaps it is because their onset coincided with a biological event. Or perhaps there is some validity to the type of intuition Descartes sometimes calls "the light of nature."[7] Because I am so certain of my own devotion, because it gradually crept up on me yet hit me like a ton of bricks, I am simply certain that intense devotion to one's child is a cultural invariant. I am certain even though I know persons within my own culture who have not felt that devotion. Odd: I am a thoughtful person, trained in and a trainer in critical thinking. Has mothering turned my brain into sentimental mush or can I guarantee "by the light of nature" that I share a basic orientation with all mothers?

A View from Outside Mothering

When I speak frankly from inside mothering, it becomes clear that powerful emotions direct my thoughts. However, in turning my thoughts towards

pacifism, it may be the case that I have given a one-sided picture of the emotions of mothering. For example, Victoria Davion has written that preservative love, one of the basic aims of mothering identified by Ruddick, can motivate mothers to engage in violence if they believe it will protect their children.[8] While Davion's essay evokes the image of a one-on-one conflict, her point is easily applicable to war. If a mother believes that a war is for defensive purposes, or that waging and winning it will afford her child a safer or even a more privileged life, then that mother may well condone a war. If Davion is right, then the emotions of mothering lead away from as well as towards pacifism. How can we untangle this contradiction in order to identify what is valuable in maternal pacifism? One method may be to examine the nature of emotion in general, and the emotions of mothering in particular, in order to see how those emotions are constructed and, therefore, how they may be constructively directed.

Alison Jaggar argues that emotions are at least partially socially constructed. Children learn the emotional responses appropriate to their culture. This learning of what is appropriate involves the expression or suppression of certain emotions. These emotional norms can serve social aims. For example, the suppression of anger by women can help to maintain an oppressive patriarchal hierarachy.[9]

Following Jaggar's suggestions, I shall call into question three specific aspects of my inside view of the experience of mothering. For each, I will speculate about the powerful social interests that are served by my identifying that experience with mothering. I will question whether I can serve those interests and still be committed to pacifism. Three aspects of my experience seem to me to be at least partially socially constructed, my beliefs that (1) the joys of mothering are gifts of grace, (2) the struggle to be a full-time caretaker is spiritually

fulfilling, and (3) the universal experience of mothering is shared by all mothers.

The view that the joys of mothering are gifts of grace and not the fruits of hard labor may, in some cases, be attributed to a woman's generally religious outlook on life. However, I believe that the construction of mothers as passive rather than active participants in a process also contributes to the view. In the United States, this construction of mothers has been exploited and extended by the obstetrical profession. The work of this profession extends far beyond the boundaries of ensuring a safe birth for mother and child. Its critics say the profession oversells the infliction of expensive and unnecessary procedures on passive customers.[10] Mainstream obstetrical practice constitutes a large and well-paid industry, a significant portion of which is devoted to "education," i.e., convincing women that birth cannot proceed safely without obstetrical intervention. In an obstetrically managed birth, a woman is treated as a passive nonparticipant just as she is becoming a mother. Often the birthing woman is reduced to a body and the body is denied any wisdom of its own. An artificial script is imposed on labor, which specifies incorrectly the normal order and duration of events. If a baby is "late," i.e., looks like it may come more than two standard deviations outside the mean arrival time, labor is induced with pitocin, an artificial hormone. *"They* induced me," mothers say. If the waters do not break by mid-first-stage labor (which they are not particularly supposed to), an amniotomy is performed. *"They* broke my waters," mothers say. If the cervix does not dilate at an even rate, a Cesarean is recommended. *"They* did a C-section," mothers say. Physicians, nurses, and now mothers assume that the birthing mother wants an epidural anesthetic, and that without it she will be unable to enjoy what some feminist authors have called "birthing labor,"[11] pain that is endured out of love for a

family. On the bright side, at least mothers who choose pain relief say *"I* had an epidural." But for the most part, the birthing mother is constructed as passive by obstetrical practice. Obstetricians who "deliver" the baby even speak as if they bring new life into the world, while the mother is merely the vessel.[12] I am not resorting to hyperbole here, but reporting on normal everyday discourse about birthing.

If the image of mothers as passive recipients of children is pushed by those who want to sell mothers unnecessary goods, then there is reason to suspect that the image is at least partly grounded in the fantasy of the advertisers, rather than in the experience of the mothers. In other words, there exists good reason to suspect that the image is a false one. And yet the correlative view that the joys of mothering are gifts of grace was an important foundation for my maternal pacifism. That view made the striving for earthly goods that leads to war appear futile, and life appear more precious as it appeared more fragile. Perhaps, then, this is not a way of thinking about mothering that can ground a serious pacifism, for a serious ethical commitment should not be founded on a lie designed to exploit the believer!

The view that the struggle to be a full-time caretaker is spiritually fulfilling is also an important component of my maternal pacifism. The image of spiritual development that I construct for myself includes training in the practice of unconditional love. However, Adrienne Rich's work in *Of Woman Born*[13] suggests that the spiritual fulfillment I claim comes from motherhood may be more of a rationalization than a reality. According to Rich, a false yet persuasive view of the meaning of mothering that developed during the rise of capitalism obscures the reality that mothering is both demanding and devalued. The falsehood finds expression in the myth that the full-time mother-homemaker has the most fulfilling life. Rich shows how the institution of

motherhood is entangled with the public-private distinction that is associated with liberal political philosophy.[14] This distinction, she argues, which sets up the home as a private place of refuge "from the brutal realities of work and struggle" is a "creation of the Industrial Revolution."[15] In order to justify paying women low wages, capitalists encouraged the view that woman's proper place was not in productive labor, that in fact woman's proper place was to create a haven for the hard-working male wage-earner. The results of this view for women, Rich says, were disastrous. The myth forestalled any examination and amelioration of the difficult life of working-class women by simply declaring that they resided in a pleasant refuge. It separated women from one another, wedding each to a single home, and leading to their powerlessness as well as loneliness. And the myth also allocated to women the responsibility for being perfectly loving, forgiving, emotional, and charmingly irrational.

Perhaps, as I imagine I am developing spiritually by working as a mother, I am in fact merely living out the role of a social subordinate who may not express anger against a status quo, but who may only express love, acceptance, and admiration for her oppressors. If this is the case, then my maternal pacifism has a shaky foundation, as it is grounded not on genuine emotion but on a mask that may hide negative and violent emotions. Worse yet, if Rich is right, then my maternal pacifism becomes a reaffirmation of my historical confinement to the domestic sphere, undercutting any public impact that my declaration of pacifism could have.

Another important component of my maternal pacifism was the view that mothers everywhere could easily come to share it, because the lessons I am learning from mothering are universal. However, Alison Bailey, drawing on the work of Patricia Hill Collins, has noted that mothers of different cultures and classes experience

mothering differently.[16] For example, what Bailey calls "racial/ethnic" mothers may see the core of their "motherwork" as ensuring the survival of children in dangerous neighborhoods; teaching children a positive identity in a dominant culture that offers them only negative self-images; and empowering themselves to retain control over their children's lives. While this may look like a variant of Ruddick's "preservative love, fostering growth and social training," simply to rename racial/ethnic motherwork in Ruddick's terms obscures the reality of the different forms that preservative love and social training must take in oppressive situations. Elizabeth Spelman has suggested that middle-class white feminists avoid looking at racial differences so that they can avoid asking themselves what role they play in the maintenance of white supremacy.[17] Perhaps my feeling that the lessons of mothering are powerful, persuasive, and universal does reflect an unwillingness to admit the existence of differences between equals. Perhaps it expresses a false hope that all good mothers share what *I*, admittedly an affluent intellectual living in a safe neighborhood in a stable country, deem important and ethical. If that is the case, then my vision that maternal pacifism has the potential for creating a mass moral equivalent to war rests upon a studied denial of the importance of the experience of mothers from other races, classes, and ethnic groups. These mothers may experience my pacifism as the affirmation of an unjust order which happens to advantage my children at the expense of their own. They may have learned that the threat of armed revolution is the only way to secure comparable advantages for their children. My studied denial of the consciousness and complaints of others can only lead away from, rather than towards, nonviolence. If the implications of Bailey's, Collins's, and Spelman's views are correct, then the version of maternal pacifism that I have outlined above has the potential to defeat itself.

An Attempt at Reconciliation

My speech from inside mothering shows that powerful emotions and the thoughts they stimulate can motivate mothers to work towards peace. My speech from outside mothering, however, reminds me that the emotions of mothering can pull mothers away from pacifist praxis. How shall I resolve the contradiction between powerful experiences and powerful arguments? I begin with the theoretical and allow it to inform the practical.

My conception of "inside" and "outside" views is strongly affected by phenomenological philosopher Paul Ricoeur's discussion in *Freud and Philosophy* of two types of hermeneutics, two approaches to interpreting texts and social practices.[18] Ricoeur calls the first hermeneutic a hermeneutic of "recollection" and the second a hermeneutic of "suspicion." A hermeneutic of recollection inspires an interpreter to remember that any social practice, no matter how bizarre it may seem to an outsider, has meaning for the practitioners. The interpreter's task is, first of all, to suspend amazement that anyone could be so naive as to accept uncritically (what appears to an outsider to be) the surface meaning of the practice. The interpreter's second task is to practice along with the practitioners and try to be moved by the meanings they find. I call a view constructed through a hermeneutic of recollection an "inside" view because it presents the data of consciousness and because it represents the experiences of those involved in a practice. In this essay, when I speak from "inside" mothering, I describe some of the profound changes in my philosophy of life that seem to have descended upon me since becoming a mother, as well as the thoughtful connections I myself have made between these new views and the rationales for pacifism.

A hermeneutic of suspicion inspires an interpreter to assume that a practice has a meaning other than the one practitioners are aware of, a meaning that is invisi-

ble to the practitioners for important reasons. The interpreter's theory about why the true meaning of the practice is hidden from the practitioners provides a key that will crack the code of the self-deception, allowing practitioners to see whose interests are served by the masking of the truth and why. I call a view of a practice constructed using a hermeneutic of suspicion an "outside" view because, in denying the veracity of a person's conscious representation of the practice, it has to rely on correlations between aspects of the practice and material conditions. Further, such a view usually begins as a view articulated by observers situated outside of the practice. In this essay, when I speak from "outside" mothering, I suggest that the meanings I often ascribe to mothering are not inherent in mothering itself. Rather, powerful groups have defined mothering in ways which benefit them, and these definitions structure my experience of the practice. This challenges the claim that mothering can motivate women towards pacifism, as pacifism purports to be an ethical principle that orients people in the world. If the very things that ground my maternal pacifism are illusions, then my principles are not firmly grounded, and are subject to change through social manipulation.

As seriously as I take these challenges, I cannot simply exit the inside view, as it describes the natural habitat in which I practice mothering. However, I can step outside that habitat periodically and reflect upon its limitations. When I return to the practice of mothering I can try to go beyond those limitations.

For example, the surprising experience of coming to have children and the hard work of caring for them has increased my esteem for the value of human life. For that reason, mothering is to be valued by pacifists. But mothering involves a focus on a single (or a small number of) human lives. Caring for those lives has pushed mothers, and could easily push me, to take a violent stand against others in order to advance or protect what

I perceive as my children's interests. Some cultural constructions of mothers (including those which construct mothers as passive or as interested only in their immediate social peers) conspire to discourage me from carefully examining my impulses to participate in collective violence.

As a thinking pacifist mother, my first response ought to be to examine these contradictions, paying special attention to the protective impulses that could deny my intuition of the value of all human life. I note, however, that in the process of protecting my children and fostering their growth, I have become committed to a number of organizations that create the communities in which I want my children to grow up. These communities are far larger than my own family. If I am to take my commitment to the value of all human life seriously, I ought to extend this work, committing myself to organizations that value increasingly wider collectives of human life.[19] Understanding this commitment as a natural outgrowth of mothering would change the meaning of mothering from a myopic to a far-reaching practice. It would extend the "practice of love" in the face of ambiguous emotions that I spoke of earlier, widening its scope beyond one's own family to the human family. Without movement towards this commitment, maternal pacifism might well be a sham, as its critics allege. With that commitment, it is a credible and creditable stance towards the world.

Notes

1. In Disney's movie "Pinocchio," the toymaker Gepetto sings this song as he is wishing for a child.

2. Sara Ruddick, *Maternal Thinking: Toward a Politics of Peace* (New York: Ballantine, 1989), 70.

3. Immanuel Kant, *Grounding for the Metaphysics of Morals*, in *Classics of Western Philosophy*, 2d ed., ed. Steven M. Cahn (Indianapolis: Hackett, 1977), 925–76.

4. See, for example, Ruddick; Jane Addams, quoted in *My Country Is the Whole World*, ed. Cambridge Women's Peace Collective (London: Pandora Press, 1984), 86–87; Olive Schreiner, *Women and Labour* (1911; reprint London: Virago Press, 1978), 170–73.

5. William James, "The Moral Equivalent of War" (1910) in *War and Morality*, ed. Richard Wasserstrom (Belmont, Calif.: Wadsworth, 1970), 4–14.

6. Ruddick, 65–123.

7. René Descartes, *Meditations on First Philosophy*, trans. Donald A. Cress (Indianapolis: Hackett, 1979).

8. Victoria Davion, "Pacifism and Care," *Hypatia: A Journal of Feminist Philosophy* 5, no.1 (1992): 90–100.

9. Alison M. Jaggar, "Love and Knowledge: Emotion in Feminist Epistemology," in *Women, Knowledge, and Reality: Explorations in Feminist Epistemology*, ed. Ann Garry and Marilyn Pearsall (Boston: Unwin Hyman, 1989), 129–55.

10. See, for example, Suzanne Arms, *Immaculate Deception: A New Look at Women and Childbirth in America* (New York: Houghton Mifflin, 1975); Nancy Wainer Cohen and Lois J. Estner, *Silent Knife: Cesarean Prevention and Vaginal Birth after Cesarean* (South Hadley, Mass.: Bergin and Garvey, 1983); Sheila Kitzinger, *Homebirth: The Essential Guide to Giving Birth outside of the Hospital* (New York: Dorling Kindersley, 1991); Susan McCutcheon-Rosegg with Peter Rosegg, *Natural Childbirth the Bradley Way* (New York: Penguin, 1984); and Christopher Norwood, *How to Avoid a Cesarean Section* (New York: Simon and Schuster, 1984).

11. Ruddick, 50.

12. For a scholarly discussion of the social meaning of medically controlled birth, see Kathryn Allen Rabuzzi, *Mother with Child: Transformations through Childbirth* (Indianapolis: Indiana University Press, 1994).

13. Adrienne Rich, *Of Woman Born: Motherhood as Experience and Institution* (New York: Norton, 1986).

14. Rich, 46–52.

15. Ibid., 49, 50.

16. Alison Bailey, "Mothering, Diversity, and Peace Politics," *Hypatia: A Journal of Feminist Philosophy* 9, no. 2 (1994):188–98.

17. Elizabeth V. Spelman, *Inessential Woman: Problems of Exclusion in Feminist Thought* (Boston: Beacon Press, 1988).

18. Ricoeur, *Freud and Philosophy: An Essay on Interpretation* (New Haven: Yale, 1970), 20–36. Ricoeur's distinction has

also been used by feminist theologians Elizabeth Schussler Fiorenza and Judith Plaskow.

19. For a related application of this idea, see the conclusion of the essay by Laura Duhan [Kaplan], "Feminism and Peace Theory: Women as Nurturers vs Women as Public Citizens," in *In the Interest of Peace: A Spectrum of Philosophical Perspectives*, ed. Kenneth H. Klein and Joseph C. Kunkel (Wakefield, N.H.: Longwood Press, 1990), 247–57.

Women Dreaming of Death:
Escaping the Burden of Young Children

Reality Sheds Light on the Dream

I had hoped it would be an intimate excursion, an afternoon of bonding between mother and infant daughter, as we took off together to the Mint Museum to visit a feminist art installation. And so it would have been, had my daughter slept half an hour longer, enabling me actually to view the installation. But just as I entered the installation's second room, she sat up quickly in her stroller. Grinning, she half-climbed, half-tumbled out of her stroller, excited to crawl the few feet she was capable of. I picked her up, put her down, glanced at the exhibit, glanced at her, picked her up, put her down, glanced, glanced, picked, put . . .

The installation explored men's suppression of women's identity. But my experience at the installation suggested that children, not men, were the culprit in my case. My child was draining me of any identity I had beyond "mother." I felt tired, ready to sleep for thirty years, to be awakened by the gentle kiss of my fully grown, self-actualized child. Or perhaps by the kiss of

my husband, competent father that he is, letting me know the job is done. "They're all set, sweetheart, ensconced in comfortable, happy lives. Now we can enjoy the things we've dreamed about. What would you like to do today?"

I remembered the fairy tales of Snow White and Sleeping Beauty, in each of which a beautiful princess slumbers indefinitely, hovering on the border of death. Then, a single kiss from a handsome prince animates the sleeper: she opens her eyes and begins to live, happily ever after. Suddenly, the temporary deaths of Snow White and Sleeping Beauty seemed attractive to me, their passive waiting nothing more than a well-deserved peaceful interlude.

But the exhibit I saw that day questioned the peacefulness of that interlude, seeing in it a far more insidious dynamic than the rest I longed for. I will discuss the views the artist and a handful of other feminist thinkers seem to have of the dream expressed in those fairy tales, and then elaborate on my own view.

The Dream

Artist Susan Brenner's photo-installation, "Exquisite Corpse," at the Mint Museum in Charlotte, North Carolina,[1] included the following text by French philosopher Helene Cixous, written in white chalk on a tar paper scroll:

> One cannot yet say of the following history "It's just a story." It's a tale still true today . . . *Once upon a time . . . once . . . and once again.* Beauties slept in their woods, waiting for princes to come and wake them up. In their beds, in their glass coffins, in their childhood forests like dead women. Beautiful but passive; hence desirable: all mystery emanates from them. It is men who like to play dolls. As we have known since Pygmalion . . . She sleeps, she is intact, eternal, absolutely powerless. He has no doubt that she has been waiting for him forever.

The secret of her beauty, kept for him: she has the perfection of something finished. Or not begun. However, she is breathing. Just enough life—and not too much. Then he will kiss her. So that when she opens her eyes she will see only *him;* him in place of everything, all-him.

—This dream is so satisfying! Whose is it? What desire gets something out of it?[2]

Before I answer Cixous's two closing questions, I need to discover what she thinks the dream is about. Is it a dream of death? A dream of passivity? A dream of subordination? A dream of recognition from another? Or a dream of the perfect union? When I have understood and chosen, I will then be able to answer another important question. Must I reject the dream? Or is there a way to embrace it, live it, aim at it, find solace in it, or transform it?

Feminist Interpretations of the Dream

Susan Brenner seems to read Cixous as describing a woman's fantasy about a man and seems to ask herself, "Why might a woman find this dream so satisfying?" Her answer stands opposite the scroll in three life-sized photos of a woman floating in luminescent sea green water, both the woman and the water clean and still. The body is draped with ladies' clothing accessories, all of them white: a chiffon shawl, a single lace glove. The eyes are closed, but not with deep sleep, as the mouth and cheeks are not relaxed in clownish asymmetry; and not with death, as no discoloration or bloating marks the body. Motionless, the woman hugs herself, as her ladies' accessories swirl around her in the water, their graceful lines interrupted only by the black metal bars the artist used to install the photographs, breaking the image of beauty in thirds.

Other texts appear in Brenner's exhibit: Shakespeare's description of Ophelia's death, alive with flora;

philosopher Luce Irigaray's reading of Plato's allegory of the cave as the entombment of discourse; the myth of Echo and Narcissus, in which all of Echo dies except her ability to mimic others. These texts confirm my suspicion that Brenner sees the dream as a dream of death. In any conversation, some must remain silent so that others can be heard. Thinking of our culture as a conversation, women's silence makes it possible for men to speak. Women's contribution to culture *is* the lack of formal representation of their experience, the burying of their desires to make a mark, so to speak. This is why women's death is so highly celebrated, so graphically portrayed: the woman who makes the best contribution to society is the one who is in many respects "dead." The dead woman will be adored by men, as she is finally doing what men expect of her—being silent. On this interpretation, the dream is satisfying because in it feminine beauty—at least men's ideal of it—is at last achieved.

French philosopher Luce Irigaray might read the dream as a dream of passivity—but a dream fantastized by men about women's passivity. Irigaray has ridiculed Freud's definitive equation of femininity with passivity, defined as inability to act on the world, given all of the exceptions and qualifications he himself had to make to that equation. Trying to make sense of Freud's resolve, and drawing metaphorically on Plato's allegory of the cave, she has described psychoanalytic discourse as a closed circle of men talking to men about what is outside their circle—women—without knowing how to pass to the outside and see reality—women—in itself.[3] The dream is satisfying to men because it is one more representation of women which confirms that the shadows in the cave are real. Irigaray's view suggests that a woman might find the dream satisfying because her education has offered her only cave psychology, destroying any other tools for self-understanding. Unable any

longer to see herself, she finds satisfaction in seeing distorted projections of herself on the cave wall.

Legal scholar Catherine MacKinnon might see Cixous's dream as either a woman's dream of subordination or a man's dream of domination. Defining pornography as representations of domination and subordination in sexual acts, MacKinnon claims that, in our society, pornography has poisoned our view of normal relationships between the sexes. Because we believe that sex is natural, we come to see domination and subordination as natural. Because we desire sex, we come to see domination and subordination as desirable, as erotically exciting. And because we believe in the equality of the sexes, we come to believe that women desire to be dominated by men as much as men desire to dominate women.[4] MacKinnon's view suggests that Cixous's dream is satisfying because it is erotic, and our society leaves her with no other way to represent the erotic.

Psychoanalyst Jessica Benjamin might see Cixous's dream as a woman's dream of recognition from a powerful masculine other. Benjamin agrees with Freud that a girl's efforts to ally with her father fail and that a girl eventually settles for an adult relationship with a man, though Benjamin gives a far more plausible explanation of those dynamics. Benjamin acknowledges that girls come to associate their mothers, who serve as their primary caretakers, with childhood and its limitations. Father, who has a life of his own, holds the key to maturity, the map for leaving childhood. Daughters therefore seek recognition from their fathers, desiring a social and psychological apprenticeship. But most fathers, seeing their daughters as unlike themselves, do not respond as daughters hope. Therefore, as adult women, these daughters continue to seek apprenticeships with men. They expect the men they love (or hope to love) to show them what to be and how to live, and to recognize and approve of them as they fulfill the men's expectations.

For these women, says Benjamin, the perfect union is one in which a man provides both guidance and recognition.[5] Benjamin's view suggests that Cixous's dream is satisfying because in it she meets the man who will recognize and guide her.

Sifting through the Interpretations

I write about Cixous's dream because *I* find it satisfying, and because I want to understand why that is so. Do I dream of being celebrated for my beauty, and am I willing to buy that recognition with my silence? Have I accepted a false definition of femaleness as passivity? Do I find the prospect of being dominated by a man erotic? Or do I dream of the recognition my father never gave me? Are these dynamics woven together in my psyche? For example, having failed to achieve the recognition I sought by being active like father, do I now try to buy it by inviting another to act for me, or by guessing his every desire and trying to fulfill it?

Although the ideas which inform each possibility give me insight into what it means to be a woman in our culture, none explains why *I* find Cixous's dream satisfying. I reject each of the interpretations, not on general theoretical grounds, for each is a good theory, but on the grounds that they do not accurately describe *me*. Of course, much of what passes for theoretical discussion is fancy rationalization of personal reactions. We try to find ways of expressing our own indignations, of defending our own interests, ideals, or self-images, in a language to which other scholars, out of the need to sustain the conventions of rational discourse which make their own work possible, are compelled to listen. But here I shall drive a bit off the road of such conventions and speak about myself.

I think that Brenner is correct in her observation that many men thrive, or think that they will thrive, off the

silence of women. Many men tremble at the idea of being corrected or interrupted by a woman, and, recognizing this, the well-bred woman listens politely until the men have finished their discourse. And a woman taking a posture of listening to a man with great approval and appreciation often appears sexually attractive to that man. However, I do not find Cixous's dream satisfying because in it I can trade silence for a recognition of feminine beauty. Although I talk a great deal, I have been told ad nauseum (though with varying degrees of sincerity) that I have conventional beauty, and I do not need to dream of a symbolic death in which I am worshipped for my beauty.

Irigaray claims that men are able to see women as passive only by ignoring a lifetime of empirical evidence to the contrary. However, in my experience, passivity *is* seductive for women. The daily trickle of family responsibilities *can* wear down one's resolve to act on the world, as simply responding to the demands of others is exhausting. But my weariness does not explain why I find the dream satisfying; rather, I am deeply disturbed by the pressure I feel to escape into passivity.

MacKinnon is surely correct that the dynamic of domination and subordination offers a powerful representation of the erotic. That dynamic offers a way of talking about some of the ambiguities of giving and taking in love. I experience this tension profoundly in the context of my greatest love, love for my baby daughter.[6] To what extent does teaching a child involve submission to their personality, interests, and needs, and to what extent does it involve guidance of their development by a parent's personality, interests, and needs? How shall I understand the endless hours of watching, smiling, listening, acknowledging, feeding, prohibiting? Where shall I find my reward, in the submission to her needs or in the domination of her development? This ambiguity is far more complex than MacKinnon suggests, and is

applicable to many pursuits and relationships. And the existence of shallow smutty pornography that reinforces rigid sex roles does not adequately account for the appeal of the ambiguity of domination and subordination. I cannot accept MacKinnon's explanation because it is too simplistic.

I like Jessica Benjamin's dream of recognition by another best of all. I dream it daily, as I hope that my accomplishments will inspire awe and gratitude in others, and, of course, as they rarely do. But, so far as I can tell, no lack of recognition from my father motivates me to return endlessly to this dream. Many evenings my father put me to bed with brain teasers and puzzles. He taught me the men's rituals in Jewish prayer, and expected me to know them along with the women's. For years he begged me to go into his profession and work with him, even hiring me as a teenager to help with accounting, foreign language translations, and legal research. Given our history together, I did experience my early years of seeking professional recognition as a simultaneous search for approval from my father. However, I conceive of my relations with lovers in terms of sharing with my brother, who, close in age with me, grew up as my best friend. My erotic ideal is probably well-described as the Dream of the Twin Brother. I can love a man if I experience him as a brother.

Constructing a New Interpretation

In each of the theories I presented, I have rejected much and accepted some. And what I have accepted can fit together into a new answer to the question, "Why is this dream so satisfying?", into *my* answer to this question. Mothering, specifically the hands-on daily care for young children's bodies and minds, is all-consuming. I do not mean that it takes up all of my time, but rather that when it is taking up my time, it takes up all of my

body and my mind. My attention, my speech, my legs and arms, respond to, belong to, another. And I fight the necessity of this, but ultimately I submit to it, for I cannot win a single battle against it, and would rather opt for peace of mind. Naturally I desire some recognition for my service, but fulfilling this desire is problematic. The person served will know no other life than to be served for at least twenty years, and will not forgive me for my personality, interests, and needs for at least thirty years.

Submission to another with no recognition of the sacrifice leads, I think, to a loss of self. I have in mind here a particular sense of the word "self." Clearly mothers of young children have a self in the sense in which philosopher David Hume spoke of the self: mothers are at least a "bundle of perceptions,"[7] that is, they continue to perceive, think, and feel. Mothers of young children have a self in the sense in which philosopher Immanuel Kant spoke of the "transcendental ego," saying "It must be possible for the 'I think' to accompany all my representations."[8] Mothers of young children are still conscious that they are the subjects of experience, although that experience often involves great interest in the experiences of others. I believe that mothers of young children lose the self in one of the senses in which philosopher Jean-Paul Sartre speaks of the self, when he says, "Man will be what he will have planned to be."[9] A mother of young children has no opportunity to actualize her plans, and so learns not to plan. Certainly a mother can plan to take the children to a party on Tuesday, or plan to feed them lunch at noon, but all plans must be plans for her to lead or follow the children. Any other plan is doomed to failure. Does mother plan to write today, while the infant crawls around on the floor? Today the infant will not crawl; she is unhappy and wants to be held. Does mother plan to wash the dishes while the toddler plays with his toys? Sorry—today's toy is Mommy's legs and the game is let's try to climb them.

Does mother plan to read today, while the preschooler draws with her crayons? Today the preschooler needs recognition and acknowledgment for every new color she uses. Does mother plan to go to a meeting tonight, while her school-age child does his homework? Tonight her son is sick and cannot be left alone. Does mother plan to take some time to herself after the children are asleep? Now she must telephone back all the relatives she put off earlier today, saying, "I can't talk now; I am busy with the children." Exhausted, with no time for self-renewal, she falls into sleep, only to begin again at—what will it be tonight?—one A.M.? half past two? With no other prospect than to lose herself in the chil-dren—for she cannot plan with any assurance to do anything apart from them—she convinces herself that she finds herself in them. And in a sense she does, for fulfilling their needs is what she needs to do.

For me, Cixous's dream is a dream of relief from mothering. I dream of escaping the loss of self, and of achieving recognition for my daily overruled desires. I dream of planning, and of the world aligning itself to actualize my plans, all the actors synchronistically real-izing that they need to play their parts in what I have planned. The dream of silent passivity is one in which I need say nothing in order to actualize my plans. The dream of subordination is one in which I need not assert myself, as the world intuits my desires and fulfills them without my asking. The dream of recognition is one in which another accepts my personality, my needs, my interests, and never implies that I must give them up in any way in order to be loved. The dream is the Dream of the Twin Brother, of two people so perfectly matched that for us to create a satisfying relationship, I need only wait. For in the dream, no adjustment, no giving, no understanding of the needs of another, no loss of self is required.

Of course, this is not the type of significant relation-ship I would want. I prefer to chafe, to be challenged, to

respond truthfully, and, as a result, to evolve. I seek
experience because it forms the self, not because it
cushions. And yet, the flip side of what I choose to, and
have no choice but to, live is found in my fantasy. Per-
haps my fantasy is a cushion, allowing me to rest now
and then in the illusion of its fulfillment, providing just
enough padding to protect me from losing myself in ful-
filling the desires of others.

In his phenomenological philosophy, Edmund
Husserl develops a vocabulary that has helped me to
distinguish between what I fantasize and what I want.
He uses the term *noema* to refer to an object of con-
sciousness, a meaning, and the term *noesis* to refer to
the mode in which a person experiences that *noema*, for
example, remembering, perceiving, imagining. The
noema (meaning) changes as the *noesis* (way of grasp-
ing it) changes. For example, a love affair experienced is
not the same as a love affair imagined or remembered.[10]
Similarly, Cixous's dream fantasized is not the same as
that dream desired. Cixous's dream is a fantasy, and it
has the meaning proper to something fantasized: a psy-
chic corrective to what is actually sought and lived. One
can and should ask what occasionally unsatisfying real-
ity the dream corrects for. But it would be a mistake to
understand the fantasy as a lived aim and ask why
women find satisfaction in pursuing death, real or sym-
bolic, for they do not. At least, I have discovered, I do
not. Instead, my fantasy is at least a comfort. At best, it
is a signpost which invites my reflective attention to rest
on my work as a mother.

Notes

1. Susan Brenner, "Exquisite Corpse" 1993, mixed media
intallation. Part of the exhibit "Memory Traces," Mint Muse-
um of Art, Charlotte, North Carolina, 1993.
2. Helene Cixous and Catherine Clement, *The Newly Born
Woman,* trans. Betsy Wing (Minneapolis: University of Min-
nesota Press, 1986), 66.

3. Luce Irigaray, *Speculum of the Other Woman,* trans. Gillian C. Gill (Ithaca, N.Y.: Cornell University Press, 1985).

4. Catherine MacKinnon, "Pornography, Civil Rights, and Speech," in *Feminist Philosophies,* ed. Rosemarie Tong, Janet Kourany, and James P. Sterba (Englewood Cliffs, N.J.: Prentice Hall, 1992), 295–308.

5. Jessica Benjamin, *The Bonds of Love* (New York: Pantheon, 1988).

6. Eileen O'Neill has suggested that images of the mother-daughter relationship can properly be called "erotic." See "(Re)presentations of Eros: Exploring Female Sexual Agency," in *Gender, Body, Knowledge,* ed. Alison M. Jaggar and Susan R. Bordo (New Brunswick, N.J.: Rutgers University Press, 1989), 68–91.

7. David Hume, *A Treatise of Human Nature* (Oxford: Oxford University Press, 1978), 252.

8. Immanuel Kant, *Critique of Pure Reason,* trans. Norman Kemp Smith (New York: St. Martin's Press, 1929), 152.

9. Jean-Paul Sartre, "Existentialism," in *Voices of Wisdom,* ed. Gary E. Kessler (Belmont, Calif.: Wadsworth, 1992), 97.

10. Edmund Husserl, *Ideas: General Introduction to Pure Phenomenology* (New York: Macmillan, 1956).

Escape from Solipsism:

The Ethical Imperative of Parenting

Introduction

According to Joseph Campbell, cultural and religious myths express truths of particular stages in human life cycles.[1] As such, they guide us to and through the various stages in our development. In this book, I have implied that philosophies are similar expressions, and serve a similar function. If so, I have found in my beginning acquaintance with the work of phenomenological philosopher Emmanuel Levinas a philosophy that helps me understand my commitment to family life.

In this essay, I shall use the philosophical idea of "solipsism" as a metaphor for a self-absorbed life. Technically, the epistemological thesis of solipsism asserts that nothing beyond a self's own experiences can be known. Relying on Levinas's view that our responsibility to others is ontologically prior to epistemological inquiry, I shall argue that the ethical commitment of parenting can shock us out of the solipsism that characterizes (a sometimes too lengthy!) adolescence. To do so, I shall sketch the problem of solipsism; introduce

Levinas's critique of Martin Heidegger's solitary search for "Being" as well as Levinas's alternative to it; identify themes in the bringing forth and bringing up of children that reflect Levinas's ideas; and, finally, sketch the ethical imperative that requires parents to abandon solipsism.

The Problem of Solipsism

As an adolescent, I was often alone, fantasizing my love life, analyzing my friendships, dissing my parents, spinning grand theories about the universe and its (dis)contents. Riding to high school one morning, with the odd alertness of a traveler wide awake in the predawn dark, I was struck by the odd lack of sociality on our commuter train: silent people sunk into themselves, scanning newspapers, finishing their sleep cycles. A hundred separate worlds, I thought, encased in a hundred separate minds, right here in this shared subway car. Later that day I drew a picture with cray-pas in order to illustrate my vision, my new lens for viewing relationships. The background was a wall of multicolored bricks. Three heads differently adorned, empty but for their outlines, stood against the background, each "plugging into" the same stream of experience at a different point. For a while, that picture expressed my adolescent metaphysics: there is a world available to all of us, not merely an external world, but a world of ideas, objectively and eternally present, through which we all move. Unfortunately, we never stand in quite the same place at the same time as another person. We share the world, that is, the stream of experience, with others, but we cannot ever swim quite where they are, nor they (especially if they are parents) where we are. I imagined this stream of experience flowing through my bedroom, and my own moods changing as I moved through the stream. Occasionally I quelled my fears of ghosts and

unidentified noises by moving to another part of the room, that is, another part of the stream, and chanting my metaphysical theory to myself.

As a young philosophy student, my intellect was dazzled by the epistemological puzzle of solipsism. How does one get beyond one's own mind to connect with a world of others? My belief in an objective stream of experience did not yield a solution. My cray-pas masterpiece, product of my untutored attempts at philosophizing, showed the impossibility of that stream's uniting us, as each person's reality is where their head is at. As I began to learn the vocabularies of academic philosophy, I found that I could not move logically out of solipsism. Once all the elements of experience are given within consciousness, I reasoned, there is no need to look beyond it. Even if objects appear to be outside of us, our only verification of this perception is given within consciousness. Indeed, I concluded, there is no way to look beyond consciousness. My empirical efforts to solve the problem of solipsism were equally enthusiastic but no more successful. My social life, directed by the desperate desire to locate a soul mate, was characterized by the disappointment and heartache that attend failure. In this regard, the theory and practice of my life were well in tune. The problem of solipsism weighted me down each and every lonely day.

Philosophically, I never solved the epistemological problem of solipsism. I just moved on. It was easy to do, as the problem of solipsism is now out of vogue in academic philosophy. Feminist philosophy has championed the idea that all human beings live in relationship. The notion of isolated individuals is just plain wrong, an artifact of an abstract liberalism designed to encourage egotistical capitalist striving.[2] Postmodernism has raised to the level of axiom the idea that we are all products of our environment. Therefore, the self abstracted from society and politics is none at all.[3] Only a self-absorbed

bourgeois theorist, probably white male, born into an economic class that avoids physical labor, has the luxury to fantasize his aloneness, or even his personal agency. He should know that his solipsistic theories are nothing but artifacts of his social location, proving once again that we are all indissolubly linked by sociality.

But however important the philosophical "schools" of feminism and postmodernism are, and however much my presentation might support them, appealing to them simply does not present the true account of why the problem of solipsism no longer seems relevant. Part of the true account is the story of the changing conditions of my life. These days, I do not spend much time alone. It no longer matters to me whether I connect with others at the same point in the stream of experience. In fact, I know that I am not at the same point as the most important others in my life, and that, in many ways, coherent communication between us is impossible. The more impossible it is, however, the more it is necessary. You see, I now have children.

In my free time, I once joked, I enjoy taking showers and going to the bathroom. Daily I am immersed in the practical problems of intelligently and enthusiastically loving others without time to replenish my energy. My attention is directed outwards from the self. As the self is no longer a starting point, the problem of solipsism is not a maze I would wander. Solipsism is both intellectually displaced and practically solved by a leap in which I "bury my . . . intentions in" others, placing them so that they appear ethically "prior to" me.[4] This sense of "ethics" is not one in which their rights against me and my duties towards them are weighed. Rather, it represents a shift in perspective in which others are simply placed before myself. When I say "before myself," I am speaking both practically and ontologically. Practically, I satisfy their needs before I satisfy my own. Ontologically, their presence makes me who I am. To illuminate

this sense of the "ethical," I shall introduce a slice of Emmanuel Levinas's project in his book *Time and the Other*, and then make use of its language to describe my transformation.

Death and the Other

Time and the Other is partly styled as a critique of Heidegger's *Being and Time*. In *Being and Time*, Heidegger characterizes death as the horizon of being that brings temporal awareness to human life. Death propels us towards the future, motivating each of us to create a life. Because death, the possibility of nothingness, is always just over our shoulders, we bury ourselves in projects, creating our human being. This awareness of death also motivates the proper philosophical project, understanding the human relationship to Being, capital B.[5] Heidegger's theory captures an important feature of life as a professional philosopher. The fear that we will not have enough time to make something of ourselves drives us to achieve. We race madly ahead of our capabilities, overfilling our calendars with projects designed to yield products, symbols of our superior intellects, stamped with our personal creativities.

But those of us who live this way would do well to remember the saying, "No one ever said on their deathbed, 'Gee I wish I'd spent more time at the office.'" It is easy to get so caught up in the search for "Big B Being," the ultimate meaning of life, that we forget about "little b beings," the people who bring lived meaning to our lives. The danger of burying ourselves in a self-imposed solipsism is real. These cautions constitute the spirit, though perhaps not the letter, of Levinas's critique of Heidegger. For Levinas, Heidegger's notion of the aim of reflection, "Being," legitimates devoting one's life to a solitary, self-absorbed quest, oblivious to the pressing cries of suffering fellow creatures.[6]

For Levinas, death does not inspire triumph. On the contrary, life inspires triumph. Only the hope that there is still some distance between us and our deaths inspires us to heroism, to taking that one last improbable chance. For Levinas, death is not a horizon that we simultaneously approach and avoid, as it is for Heidegger. Rather, death is beyond any horizon of human consciousness, absolutely unknowable, absolutely other. Oddly, however, the event that mires us most deeply in our own consciousness reveals to us the possibility of death. Physical suffering can be inescapable, the experience of "the very irremissibility of being."[7] Yet when we suffer, we often worry that death is near. Our immersion into being is inseparable from our knowledge that something radically other than our being exists.

This other is, but is not merely, the abstract other of death. When we fantasize about our own deaths, we worry about leaving bereaved those who love us and depend upon us. We recognize that their lives, their consciousnesses, will not end when ours does, just as ours did not end when we grieved over the passing of our intimates and heroes. The possibility of death stings us with the absolute mystery of other persons: completely distinct from our consciousness, yet face to face with us. For Levinas, any inwardly directed inquiry into Being will point us towards what is radically other: the consciousness, the existence, the face, the call of another person. The possibility of responding to that call is the horizon of being that brings the urgency of action, and hence the awareness of time, to human consciousness. For Levinas, the future is the Other.[8]

Presented in this language, Levinas's ideas sound noble, yet abstract, way larger than life. However, I shall show that these ideas are not abstract, but are existentially concrete, by speaking of my movement from suffering to responsibility for the Other.

Birth and the Other

I speak here of the suffering of morning sickness, a ridiculous, belittling name for the twenty-four hour nausea that characterized nine months of both my pregnancies. In pregnancy I experienced a profound loss of self—not in any speculative psychological sense of confusion about my changing identity, but in a very concrete sense. I lost all interest in my activities, in teaching, socializing, even eating and bathing, the daily sensuous treats of a well-appointed life. Yet, especially in my second pregnancy, I dragged myself through them so as not to experience a total loss of connection with my daughter, my husband, my job, the things I love when I am capable of loving. On my knees each morning, nauseated, I bent over the bathtub, bathing my daughter.

Immersed in morning sickness, my life seemed as though it had no direction, each day as if it had no particular goal. Suffering was diffused throughout everything that entered my consciousness. The irremissibility of being, that is, of being in pain, was utterly overwhelming. My consciousness shrank; it grew dull, creating distance between me and my life, making reaching out towards life an exhausting activity. In the entire first trimester of my first pregnancy I managed to write one sentence in my journal. "From my seat on the couch," I wrote, "I can see my entire world: branches of a tree framed against a patch of blue sky in wan autumn sunlight; all that remains of life and hope." I thought often of my mother-in-law, who was at that time dying of cancer, imagining I understood the gradual shrinking of her life into pain and apathy.[9]

But, though I experienced a deadening of consciousness, I was not in fact moving towards death. On the contrary, I was moving towards life, towards the introduction of new life into this tempest we call "the world." But the prospect of this new life did not function as a

joyous horizon that brought meaning to the experience of suffering; the irremissibility of pain did not allow me that. The joy of the new life expected was something completely other, unimaginable as the flip side of my experience of pregnancy sickness.

Perhaps it is good that excitement and expectation did not pervade my pregnancies. For each new life, each new other, is unlike the others we have already encountered. On the one hand, it does not take much to know about baby care, and many of the steps in a child's development are predictable. On the other hand, the person growing inside me, about to be birthed, was supremely unknowable. How would I feel when I looked upon her or his face? What ecstasies and disappointments would that face reveal and hide over the next twenty years? On what journeys would that face and the consciousness it expresses take me? Relationship with this other was and is a relationship of mystery. Relationship with this other is relationship with the future; and the future, of course, is unknowable, mysterious, and surprising.

Parenting and Phenomenological Ethics

I meet this mysterious future, my future, my child's future, with only one unshakable resource: the commitment to care about it, whatever it may bring. My child could become retarded, disabled, chronically ill, or just plain mean. Any of these setbacks would cause me considerable pain. But even in the face of my pain, only one ethical course of action could present itself: respond to my child's needs, whatever they might be. Though the precise implementation of that imperative would always be open to deliberation, the imperative itself would not.

As Levinas scholar Richard Cohen says in his introduction to *Face to Face with Levinas*, for him and for

Levinas, truth must serve the good, and not vice versa. The criteria of ethics take precedence over the criteria of epistemology because ethical necessity is prior to knowledge, more compelling than any conceptualization of Being or essence that thought is able to thematize. As Cohen says, "ethics . . . disrupts the entire project of knowing with a higher call, a more severe 'condition': responsibility . . . [which is a] relationship with the alterity of the other person in an obligation to respond to that other."[10]

Therefore, I have now discovered, it is ethical necessity, not logical necessity, nor a passive riding of the currents of the life cycle, that has solved the problem of solipsism for me. I cannot be both a good parent and a solipsist. To be a good parent, I must be immersed in, engaged with, answering and changing in response to the needs and desires of the other. It would be impossible, in good faith, to wonder seriously whether a child exists only as the fantasy of my own imaginative creation. For as much as children are made from the matter of their biological parents, they are other than those parents, with unpredictable calls and responses. The extent of children's otherness is a continuous surprise to parents. Fantasies of perfect control over children are normal, yet trying to act them out produces anxious parents and crazy children.[11]

Even if parents choose to acquire children for selfish reasons, designating those children to play a pleasing role in their parents' life, the reality of raising children shatters a parent's self-absorption. For while parents say that the rewards are great, they are scant compared with the sacrifices. What reward is worth the sacrifice of one's sleep, health, leisure, money, and identity? What reward is worth the risk of one's happiness, should the child suffer or die unpredictably? There is no such reward. Parents respond to their children because the call of a child is an ethical imperative.

Conclusion

In order to restate what grounds this ethical imperative, I shall restate Levinas's argument and my application of it.

We reach Being through an indirect proof, by imagining the lack of being, that is, death. The essence of death is captured in the mysterious fact that while our consciousness ends, that of others lives on. The mysterious givenness of others, therefore, makes plain our human essence. As the existence of others is prior to our consciousness, response to them is the imperative of human existence. This imperative makes us plan, act, and look towards the future. The future, mysterious and surprising, lies within our response to the mysterious others that people our world. Therefore, the imperative to respond to others, labeled the "ethical" imperative, is prior to any particular cogitations, as it gives us our consciousness and our future.

Children are a paradigm case of the mysterious other that points us towards the future. And responding to children is one way to fulfill the ethical imperative of being: confronting that which is outside ourselves. Although solipsism may be logically unassailable, human nature renders it ethically incoherent.

Notes

1. Joseph Campbell with Bill Moyers, *The Power of Myth* (New York: Doubleday, 1988).

2. Naomi Scheman, "Individualism and the Objects of Psychology," in *Discovering Reality: Feminist Perspectives on Epistemology, Metaphysics, Methodology, and Philosophy of Science*, ed. Sandra Harding and Merill B. Hintikka (Boston: D. Reidel, 1983), 225–44.

3. See, for example, Michel Foucault, *The Foucault Reader*, ed. Paul Rabinow (New York: Pantheon, 1984).

4. See Maurice Merleau-Ponty, *Phenomenology of Perception*, trans. Colin Smith (New York: Humanities Press, 1962), 82.

5. Martin Heidegger, *Being and Time*, trans. John Macquarrie and Edward Robinson (New York: Harper, 1962).

6. Richard A. Cohen, *Elevations: The Height of the Good in Levinas and Rosensweig* (Chicago: University of Chicago Press, 1994), 287–96.

7. Emmanuel Levinas, "Time and the Other" (1947), *The Levinas Reader*, ed. Sean Hand (Cambridge, Mass.: Basil Blackwell, 1989), 37–58.

8. Ibid. See also Richard A. Cohen, introduction to *Face to Face with Levinas*, ed. Richard A. Cohen (Albany, N.Y.: State University of New York Press, 1986), 1–10.

9. For a different view of the experience of pregnancy, see Iris Marion Young, "Pregnant Embodiment: Subjectivity and Alienation," in *Feminism and Philosophy: Essential Readings in Theory, Reinterpretation, and Application*, ed. Nancy Tuana and Rosemarie Tong (Boulder: Westview Press, 1995), 407–19.

10. Richard A. Cohen, "Translator's Introduction," in Emmanuel Levinas, *Time and the Other*, trans. Richard A. Cohen (Pittsburgh: Duquesne University Press), 1–27. Quote is on p. 5.

11. Sara Ruddick, *Maternal Thinking: Toward a Politics of Peace* (New York: Ballantine Books, 1989).

Speaking for Myself in Philosophy:
Alternative Conceptions of the "Empirical"

As I have progressed along the journey described in this book, my own life has become increasingly intertwined with the lives of others. My thoughts have been molded by the influences of my parents. Control over my daily routine has slipped out of my grasp, and my activities now serve the organization and maintenance of my children's lives. As a result, my own life has become less abstract. No longer am I an individual with vaguely defined ambitions and haphazardly developed talents looking for a focus. No longer do I spin theories and wonder when I might have the opportunity for life experience to put them to the test. Instead, my daily life is rigidly structured, and the commitments it allows are clear. I have time only for exploring theories that arise from my concrete practice, and for exploring them within my practice. To my delight, I am discovering that this practice is engaged with many important philosophical issues, from metaphysics and epistemology to ethics and politics. Therefore, instead of lamenting my changed ability to participate in philosophical theorizing, I find

myself desiring to find in academic philosophy the same level of engagement. However, when I survey the work being done around me, that engagement with concrete daily living often seems absent.

Most academic philosophers write in a rather peculiar literary genre. This genre invites a way of reading, and creates an emotional context for that reading. The reader experiences boredom, and makes a conscious effort at concentrating. Boredom is invoked by a stylized structure which signposts itself as logical. Concentration is required to interpret abstractions which are torn from the context in which they came to have sense. Readers also experience eyestrain, as the print in academic books and journals is usually very small. This is intended, no doubt, to make the reader feel at once as though she or he has been poring over the texts long into the night, in a makeshift study or poorly funded rare books collection, under a dim and barely sufficient light.

This is not how I want my readers to feel. I want them to feel as though skeins of conversations, relationships, activities, regrets, joys, and indignancies are reweaving themselves. I want them to feel as though a pile of broken triangles, representing pieces of their lives, formerly seen through a kaleidoscope, are beginning to rise into a recognizable shape. To this end, I offer them the broken triangles of my life and the arrangement of mirrors I have discerned in the kaleidoscope.

I find that my writing has, of its own accord, shaped itself into the contours of a genre that Philip Lopate has named "the personal essay."[1] In the personal essay, a writer describes intimate personal experiences in order to point the reader towards a recognition of some larger insight about life and/or society. Lopate writes that the personal essay, which winds through an author's often inconsistent thoughts and experiences, reflects a

multiplicity of selves "that [all] human beings harbor." In the successful personal essay, this winding represents a pursuit of honesty, as each new revelation by the author is also an opportunity for further investigation of the sincerity of that revelation. The writer's revelations are interesting to the reader because, as Montaigne wrote, "Every man has within himself the entire human condition." While Montaigne wrote in a time when intellectuals were not always sensitive to the profound cultural differences between people, I do agree that a personal essayist's particular concern can reveal themes of general concern to many readers.

Literary genre is more than a convenience which makes information easily accessible in a familiar form to readers. It is also a language game whose rules allow certain moves, prohibit others, and define what would count as a winning move. Therefore, as I immersed myself in the genre of the personal essay, my conception of the nature of philosophy began to change. Initially I was attracted to the personal essay because its three defining characteristics—giving voice to multiple selves, honestly pursuing self-revelation, and presenting the general in the guise of the concrete—seem to overlap with some of philosophy's characteristics and concerns. Many philosophers have recognized the multiplicity of the self, philosophy has styled itself as the quest for truth, and philosophy has traditionally sought to formulate universal truths. These three propositions, one of which takes a position on an area of philosophical concern and two of which are classic components of philosophy's self-definition, are usually understood in a way which both shapes and justifies standard academic philosophical writing. As I began to adapt my thinking to the genre of the personal essay, I began to reinterpret each of these propositions in a way which reflects the personal essay. I shall comment on each of the three propositions in turn.

The goal of a good academic essay is to dissolve all contradictions between the arguments and objections the author proposes and come to a unitary conclusion. In other words, though an author may speak in multiple voices in the course of the essay, a successful conclusion is reached when one voice wins out over the others and speaks alone, confidently. Sometimes, however, an author fails to reach this goal, and must be content to present her or his conflicted thinking while concluding with a list of contradictions that still need to be resolved. Similarly, a belief in the multiplicity of the self is often the result of a failed search for a unified self. For example, Plato is the earliest of our philosophical authorities to describe the multiple and conflicting selves that make up the human soul when he described the (usually unsuccessful) struggle of reason to control spirit and appetite.[2] As if confirming Plato's account, David Hume acknowledged that playing billiards made it awfully difficult for him to remember why he found philosophy to be important. In his philosophical hours, he recognized that he could not find a principle of unity for the self that made any sense to him.[3] But why am I suddenly appealing to philosophical authorities? Surely I needn't check Hume's experience to know that at one moment in a typical day I am a driver cursing at the plodding pedestrians detaining me at the crosswalk while at another moment I am the self-righteous pedestrian in the crosswalk, thinking at the drivers, "They can wait. It's the law." Here I am reminded of Lopate's observation that the personal essay has a democratic bent. Academic philosophy, on the other hand, has an aristocratic bent, phrasing its insights in in-group jargon, referring to experts only people trained to Ph.D. level can cut a path through. As I listen to myself, I hear my democratic and aristocratic selves dealing out their perspectives. One moment I am padding and shaping my own insights with those of acknowledged

philosophical masters; the next moment I am correcting myself sharply by invoking the mundane task of driving around town.

The multiplicity of selves to which I want to give play are not only the selves with different ethical sensibilities but also the selves which live and the selves which theorize. My theorizing selves have been formally educated in theorizing; my living selves have been educated through living, with the help of the theorizing selves. As I try to understand my experience, I generalize, I theorize. As I try to understand the theories I've constructed, I try to use them to understand my life. The background to my academic work is my life: I consort with philosophers who write about peace because loss makes me cry; I teach about ethics because understanding it gives me the strength to solve my problems and help others solve theirs; I serve the women's studies program because feminism has made me see institutions and relationships differently; I write about the self because I see how motherhood steals it as much as deepens it. These experiences are more than motivations, more than the crack of a starter pistol, for diving into the arcane, for learning and living its peculiar language and canons. Rather they are ongoing reference points, which enrich and are enriched by my academic work. In many ways, both the basis and the telos of my scholarly work is ordinary knowledge, rich in emotion, embedded in relationships, unsystematic in its choice and use of sources. I believe that my academic work will be enhanced, not contaminated, if in my writing I place my theorizing in the context of concrete experience. Such a placing makes theory deeper, by making the entire web of life available for interpretation by it and of it.

By generally avoiding this placing, the academic approach to philosophy shows that it finds truth through a careful pursuit of the logic of justification.[4] The presentation of justification seems to assume an

audience who is alienated from the experience of discovery. Philosophical "truth," typically, is not found in the moment of discovery, not anchored in the shift of perspective through which what previously was confusing now makes sense.[5] To philosophy's credit, sanity and judicious sobriety inform this reliance on the logic of justification, as seeing anew does not guarantee seeing rightly. But I am disturbed by the fact that any attempt to get readers to empathize with or share the experience of discovery is dismissed as merely "persuasive" writing. After exploring the personal essay, I believe that such persuasive writing carries the potential for discovering truth. I am speaking now of moral and epistemological truth, the truth about what we know, care for, and hold dear; and the truth about how we know, care, and hold dear. That truth is always changing, as the circumstances of our lives change. As that truth is embedded in the lives we live, the best way to expose it is to describe those lives, or, better yet, to describe the guises that a life takes on as we try to understand it, impose a shape on it, point it in a particular direction.

I find after experimenting with the personal essay that philosophical truth becomes lived truth and that philosophical honesty becomes the continued mining of one's self-understanding when one is willing and able to say how one lives. Timothy V. Kaufman-Osborn has paraphrased Richard Rorty to say that "There is . . . no meaningful way to distinguish between someone's experience and the language used to talk about it."[6] What drives the personal philosophical essay is the instinctive hope that Rorty is wrong about this. Honesty in such an essay is a search for the gaps between experience and our descriptions of it. It is the search for a way of understanding and adopting theories so that they point out the gaps, insincerities, and dark spaces in our ordinary self-understandings. It is a search for ways of understanding our relationships, projects, or desires

that point out the gaps in our theories. This search places no constraints on what counts as experience. Experience includes everything that an author can find a way to articulate, as well as sensations, thoughts, memories, and emotions that the author is not yet able to, but aims to, articulate.

Following upon the requirements of the logic of justification, academic philosophers define truth as general when it offers a definitive description of every human life. To make a truth look like it applies to everyone, examples which showcase the particularities of discovery are avoided, as they might particularize the insight to one time and place. After experimenting with the personal essay, I have come to define a truth as universal in the way that Lopate implicitly defines it. Because the personal essay invites the reader to self-discovery, Lopate sees a truth as general when a majority of readers recognize themselves in it. And, he thinks, the best way to invite this recognition is by describing one's own experience. Maria Lugones's essay "Playfulness, 'World'-Traveling, and Loving Perception" offers a wonderful illustration of this genre adapted to philosophy.[7] The question of world-traveling became important to her because she reports that she came to forgive and love her mother when she learned to travel into her mother's world. Although I am not motivated through friendship or prurient interest to care about the details of Lugones's relationship with her mother, I am always looking for ways to love and understand my own mother. Lugones's essay holds my interest for two reasons: it is interesting to read, because it is anchored in a story, her story; and it is challenging to read because as I read I think of my own story as a daughter. Descartes's *Meditations*, though they are written in the first person, offer a lousy example of finding the general in the particular.[8] Although Descartes speaks in the first person, he does not reveal the story in which his discoveries are embed-

ded. For example, Descartes does not tell us how he came to question the line between dreaming and waking. There is no compelling description of a vivid dream that he confused with reality, and of the questions that flowed from that. There is no description of a concrete experience that resonates with readers because it is general. Instead there are carefully staged arguments for and against various levels of certainty. Lugones showcases the steeping of her theories in personal experience. Descartes showcases his careful paring down of claims to those that can be shown to be universally true. But he ends up writing a book which is not universally, or even generally, true in the sense of the term articulated above. My students sometimes recognize themselves in Descartes's questions, but almost never in his answers.

I do not mean, in this book nor in its penultimate essay, to be claiming, as some formerly radical, now merely liberal, philosophers do, that academic philosophical writing has outlived its usefulness in this postmodern age in which no definitive criterion of truth can help us sort through the multiplicity of personal and cultural images. The project of discerning the shape of absolute goods, like justice, love, and knowledge, still holds me in thrall and in fact motivates my personal-philosophical musings. I mean instead to present an alternative to most of academic philosophical writing which aims at, though reinterprets, traditional philosophical goals. This style of writing, which celebrates the logic of discovery, could be useful to those who fear, as I do, that focusing on the logic of justification edits the thinker out of the work. The personal essay might be welcomed by those who worry that justifying ideas without reference to their context of discovery is dishonest. Those two concerns have certainly nagged at my professional writing. I came to graduate school in 1984 with something to say about phenomenology and

human creativity. When I left in 1990, having written a dissertation about phenomenology and human creativity, I somehow felt as though I were no closer to speaking my mind. Oddly, I was not sure what my dissertation was about. In job interviews, I was unable to say clearly what areas of philosophy I was interested in.

In retrospect, I recognize that my philosophical writing had been perverted by the very qualities that made me a good student. I desired to model what my graduate trainers insisted were the canons of good academic writing: brushing aside the merely personal logic of discovery to highlight the publicly accessible logic of justification. The logic of justification required that instead of explaining why I came to believe something, I was to explain why a reader with a Ph.D. in philosophy should believe it. Instead of contextualizing my insights by explaining the circumstances that led me to ask a philosophical question, I was to present a review of literature raising similar questions, and pretend that I was responding to that literature. The more sophisticated I became in academic philosophy, the more adept I became at finding resources to justify my ideas. At the same time, however, it became more difficult for me to say what I wanted to say. I spoke in the voices of others instead of in my own voice. Therefore I was never quite sure what I was writing about.

For example, my dissertation was about the power of analogy to produce conceptual, ethical, and political shifts. I knew of analogy's power *because,* for example, I came to understand racial oppression by analogy to women's oppression. Yet I could not present my transformation as evidence. I had to review the literature on analogy and metaphor, presenting a conclusion about the type of linguistic phenomenon analogy might be and a theory of how a linguistic phenomenon could produce a conceptual shift. This is important philosophical work, of course, *but it was not what I wanted to say.* I

wanted to say what I had discovered, and how I had discovered it. Saying that, I felt, would not only be true to myself, but would also allow me to inspire others to interrogate their experiences as well.

I must acknowledge that many of the criticisms I make of academic philosophical writing have been made before, not in the context of championing the personal essay, but in the context of rescuing philosophy from the hungry jaws of the positivistic paradigm of science. Herbert Marcuse, for example, criticized what he called "positive philosophy," forced to affirm the intellectual status quo because it is modeled on positivism, and celebrates what he calls "negative philosophy," which reveals the ideological and social forces which shape the status quo.[9] Janice Moulton criticizes the "Adversary Paradigm" which requires philosophers to dialogue by scrutinizing the arguments rather than the intentions of others. She suggests, as an alternative, that philosophers attend to the experiences which shaped the philosophies of others.[10] Gabriel Marcel criticizes the scientific reductionism of much of contemporary philosophy and suggests that philosophy use human rather than mechanical metaphors.[11] And Genevieve Lloyd criticizes the narrow technical conception of reason which guides philosophy and suggests that we remember the classical Greek conception of reason as an ethical ideal.[12] Therefore, in this next section, I weave my observations about the virtues of the personal philosophical essay into a criticism of the positivistic bent in contemporary philosophy.

One evening I, a frustrated mother, was having a difficult time convincing my equally frustrated infant daughter that she was ready for sleep. I held her, walked her, rocked her, sang to her as she protested angrily. In her overtired confusion, she began beating on my face with her open palm. Out of the corner of my eye, because it was hard to look directly at someone whose

face was so close to mine, I caught a hint of a smile at the corner of her lips. "She thinks it's funny!" my husband said.[13] "If that isn't aggression . . ."

Although I stopped her aggression, I forgave it, recognizing her frustration at my inability to ease her pain, the intense pain that newborns always feel and older infants sometimes feel as the bodily discomfort of fatigue or hunger overwhelms them. Later I wondered if my insight into her aggressive behavior could be generalized. Perhaps it could be said that aggression is often motivated by pain. But there are many contexts in which people act aggressively where pain seems to be irrelevant. For example, some aggressive acts, such as war-making, seem to be coldly instrumental rather than hotly expressive. Could these contexts fit into my theory? Does one learn to hurt others, coldly ignoring their pain, because one has learned to coldly ignore one's own pain? It would seem that this is an empirical question. When I encounter aggressive persons, I need to observe them carefully, scrutinizing their speech and behavior for traces of pain that might motivate their aggression.

My husband, however, informs me that my study is not a proper empirical investigation. It is too subjective. There is no way of ensuring that another person would recognize aggression or pain where I recognize it. Discussing our observations is not sufficient, for we may not share criteria for identifying "aggression" or "pain." We do not have what he calls "inter-rater reliability." Such reliability, he claims, is only possible if both observers quantify their perceptions using an agreed-upon scale. So I asked him, "How would one empirically test the hypothesis, aggression is a result of pain?"

He gave me two answers. If we don't have to worry about ethics, he said, the test would be pretty straightforward. Take two groups of people who are equal on measures thought to determine personality, such as temperament, intelligence, socioeconomic standing, or

family upbringing. Ideally the two groups would have been brought up identically since birth in preparation for the experiment. Subject one group to psychological or physical pain. Then count the frequency, duration, or intensity of aggressive acts committed by the people in the two groups. If the group submitted to pain commits more aggressive acts, then the hypothesis will be borne out.

However, if we want to conduct an ethical test (and we do, he added), we begin by operationally defining pain in terms of a list of painful experiences. Take a random sample of people from all walks of life. For each person, rate the frequency, intensity, and duration of each painful experience. Then count the number of aggressive acts each person commits. Use the statistical technique called "multiple regression" to learn which combination of painful experiences best predicts aggression.

Who would be interested in the results of this study, I asked. How would they use it? He reeled off a list: Departments of Social Services, the criminal justice system, psychotherapists, teachers. DSS and related agencies would use it to try to intervene in families to eliminate sources of pain. The criminal justice system might use it to help decide whether a perpetrator is "incorrigible" or fit for rehabilitation. Psychotherapists would use the information to help aggressive people overcome aggressive behaviors. Teachers might use it to understand aggressive students and to work with them. I object: all these people are experts in the field of human relations. Why do they need statistical confirmation of their insights into their clients? He answered without hesitating: public officials are accountable to the public; private practitioners to their clients and their licensing bodies. Imagine the lawsuits they would lose if they could not justify their policies with anything besides their own judgment. Lyotard has written that the rise of

the grand narrative of the epistemological power of science coincided with the rise of political bureaucracies.[14] Perhaps my husband, who has not read Lyotard, has recognized that a bureaucrat's need for certainty in the absence of direct contact with the object about which certainty is needed is well-served by the authority of scientific proof.

My husband and I have very different views about how one answers an empirical question. My husband's brand of empiricism is positivist empiricism—not surprising, of course, since he is a trained "social scientist." His understanding of empiricism is sifted through the mythology of science. Insights must be verifiable by a trained experimenter. To control for differences between experimenters, verification must be in numerical form. In other words, experiments must take place out of the context in which phenomena were first considered to be important or meaningful, if insights are to be universally valid. The type of answer we seek cannot be directed by the context in which the question was raised. A process of exploring the hypothesis by living as though it were true will not yield empirically valid information, since the experimenter's perspective may change in the course of the exploration.

My brand of empiricism is faithful to its roots in the Greek word "empeiria," experience. A question arose in the course of my experience, and I propose to answer it using my experience. I propose to study phenomena as they present themselves in my experience, in their natural habitat, so to speak. The type of answer I seek to my question about aggression and pain is directed by the context in which I ask it. Someone I love is hurting me. How do I prevent them from hurting me without hurting them? I seek to understand the cause of their aggression so that I can comfort and advise them, rather than attack them in return. I will learn the answer through observation, interaction, and reflection. Many

answers will emerge over time, answers which are appropriate for the many different aggressive people in my life, answers connected by a loose set of generalizations that will emerge only when I am called upon to speak about my theories. The answers, as well as my quest for them, will be lived.

The repudiation of a positivistic conception of empiricism offers a significant challenge to academic philosophy. Academic philosophy, as most of us were taught it, and as many of us now teach and write it, has been structured by a positivistic conception of empiricism. Philosophical musings are called "knowledge" only if they are taken out of the context of experience in which they are first intuited. Statements must be universal generalizations about (for example) "the self," "government," or "phenomena." Insights must be supported by logical argument presented, as I said above, in a stylized structure which signposts itself as "logical." We are encouraged to use examples, but, oddly, we rarely use the examples which led us to discover an insight. Rather we use made up examples to illustrate scattered points, examples which cannot serve as anchors for an entire text, cannot illuminate the significance of a theory, cannot invite readers to grasp it by analogy to a similar experience in their lives. To speak in the terms used in the essay "Symbiotic Stories," our writing often displays an outer life as defined by the philosophical community, but hides its inner life. And such an undue emphasis on meeting the demands of outer life has its effects on the inner life. Gradually, our wonderings about the world are molded into conventional forms. If philosophy is about creating an examined life, then leaving out the life which philosophy examines seems to sabotage its aims.

My writing now lingers on the logic of discovery, as my student writing failed to do. Each of my essays tells someone's story, often, but not always, my own.

Through these stories, all of which point readers explicitly towards philosophical theories, I hope to inspire a shock of recognition in readers, who might then try to take the conclusions of the essays up into their lives. The contents of the essays are issues that arise when one takes the personal essay seriously as a genre of writing and thinking. The questions I discuss include, How can I reconcile theories I have learned with experiences I have lived? Caring for my infant daughter, now a toddler, has ripped a schism between the theories I once believed and the practices I now follow. How does a careful scrutiny of my practices shock my self-satisfied ethical sensibility out of its complacency? Exterminating fleas has shocked me into reevaluating my belief that I respect life. How can I, in good faith, live two inconsistent perspectives? Complimenting a fisherman on his catch although fishing disgusts me has reminded me that I don and shed personas as my aims require. From whence do I draw the resources to grow ethically, spiritually, and intellectually? Smoldering as my mother pushes my emotional buttons has afforded me a glimpse of a larger, more confident, self-image. My answers, as well as my questions, weave a personal and philosophical tapestry of ideas, relationships, regrets, and joys in which I hope readers will both lose themselves and find themselves.

Notes

1. Philip Lopate, *The Art of the Personal Essay: An Anthology from the Classical Era to the Present* (New York: Doubleday, 1994).

2. See Plato, *Republic* and *Phaedrus*, in *Plato: Collected Dialogues*, ed. Edith Hamilton and Huntington Cairns (Princeton: Princeton University Press, 1961).

3. David Hume, *A Treatise of Human Nature* (Oxford: Oxford University Press, 1978).

4. For an explanation of the distinction between the logic of discovery and the logic of justification, see Karl Popper, *The Logic of Scientific Discovery* (London: Hutchinson, 1952).

5. For a beautiful description of truth as seeing in the light of new perspectives, see the chapter entitled "Truth" in Gabriel Marcel, *The Mystery of Being* (Chicago: Regnery, 1950).

6. Timothy V. Kaufman-Osborn, "Teasing Feminist Sense from Experience," *Hypatia: A Journal of Feminist Philosophy* 8, no. 2 (spring 1993), 124–44.

7. Maria Lugones, "Playfulness, 'World'-Traveling, and Loving Perception," *Hypatia: A Journal of Feminist Philosophy* 2, no. 2 (summer 1987): 3–19.

8. René Descartes, *Meditations on First Philosophy*, trans. Donald A. Cress (Indianapolis: Hackett, 1979).

9. Herbert Marcuse, *One-Dimensional Man* (London: Ark, 1986).

10. Janice Moulton, "A Paradigm of Philosophy: The Adversary Method," in *Women, Knowledge, and Reality: Explorations in Feminist Philosophy*, ed. Ann Garry and Marilyn Pearsall (Boston: Unwin Hyman, 1989), 5–20.

11. Gabriel Marcel, *The Mystery of Being*, 103–24.

12. Genevieve Lloyd, "The Man of Reason," in *Women, Knowledge, and Reality: Explorations in Feminist Philosophy*, ed. Ann Garry and Marilyn Pearsall (Boston: Unwin Hyman, 1989), 111–28.

13. Charles Kaplan, department of psychology, University of North Carolina at Charlotte.

14. Jean-Francois Lyotard, *The Postmodern Condition: A Report on Knowledge* (Minneapolis: University of Minnesota Press, 1989).

Philosophical
Afterword

Symbiotic Stories:
Our Inner and Outer Lives

The Thesis: Inner and Outer Life
Mutually Define One Another

We speak of having an "inner life," by which we usually mean our aspirations, our emotional ties with others, our attempts to find meaning in what we do. We also speak of having an "outer life," by which we mean our jobs, our concrete relationships, our daily routines. Here I deliberately chose examples which make it look like "inner" and "outer" life are closely intertwined. And they are: our outer life represents our best attempt to embody the inner life, while our inner life represents our best efforts to understand and direct the outer life. But this is no more than (and, I should add, no less than) a poetic expression of commonsense psychology. In this essay, I'd like to express the point philosophically, and then use it to suggest that philosophy, one of our attempts to find meaning in our lives, is closely intertwined with our concrete relationships and routines.

129

Using David Denton's simple definition of metaphor as an attempt to grasp linguistically what is around us when it is difficult to do so,[1] I shall suggest that what we refer to as our "inner life" is an attempt to speak metaphorically of what we refer to as our "outer life" and vice versa—that what we refer to as our "outer life" is an attempt to speak metaphorically of what we refer to as our "inner life." In support of this point, I shall present a phenomenological argument from experience drawing mainly on the work of the existential phenomenologist Gabriel Marcel. Specifically, I shall rely on Marcel's description of the complexity of our emotional lives. Next I shall present a more technical argument based on an analysis by the deconstructionist Paul de Man of a canonical text in modern empiricist epistemology. Specifically, I shall use de Man's demonstration that John Locke's distinction between "mind" and "world" as presented in Locke's *Essay Concerning Human Understanding* collapses when examined closely. Finally, I shall use Max Black's more detailed analysis of metaphor to argue that philosophy and daily life can also be seen as metaphorical expressions of one another.

I will begin with a fact rather than a philosophical theory: we speak of both an "inner" and an "outer" life. Jacques Derrida argues that language does not refer to reality in any sense that would be compatible with a correspondence theory of truth. He says that there is no presence behind the veil of language; language only creates such illusions about the things to which it invites us to attend.[2] If Derrida is right, then it would be futile to establish the existence and precise nature of either the inner or the outer life. I would do very well to begin with the fact that we have these two figures of speech which help to make speech about ourselves possible. After making this disclaimer, I present my arguments below.

A Phenomenological Argument

James Edie has defined "metaphor" as an expression which gives the name of a concrete phenomenon to a relatively indistinct phenomenon. The name of the concrete object is extended to a less concrete aspect of experience which is similar to it in some way. Because of the way language directs as well as follows our attention, those similarities will turn out to be the aspects of the indistinct phenomenon to which we are most likely to attend. Relying on the phenomenological principle of "intentionality"—which says that consciousness is actively directed outwards—Edie reasons that originally most words named or described what he calls "concrete world-phenomena." Our language for speaking of our inner lives, he concludes, must therefore consist of metaphorical extensions of expressions which describe our outer lives.[3]

If I apply Edie's theory, which is meant to apply to the linguistic history of the human race, to an individual's personal history (recognizing the extent to which it is also a social history), then it becomes clear why our inner and outer lives appear to be so closely intertwined. We can only speak of our aspirations in terms of what we do and what we see; we can only speak of our emotional ties with others in terms of what we do with and see of these others; we can only speak of the meanings of things in terms of the things themselves. Our inner life is a mirror of our outer life.

I have two objections to Edie's theory. First, I question its historical accuracy. Edie's theory displays what Maurice Merleau-Ponty would call "the prejudice towards the objective world."[4] Edie asserts that human experience of the "concrete" or physical world has primacy over human experience of an abstract or psychological world—without giving any good reason for that assertion. I would imagine that Edie's theory is informed by a popular image of natural history: Neanderthal or

Cro-Magnon people huddling together for survival, try-
ing to build or use tools—dealing with "concrete world-
phenomena" for sure! But this unarticulated and undis-
cussed image proves nothing about the nonexistence or
lack of status of the inner life of early humans. Second, I
question the extent to which Edie's theory is true to our
experience of the relationship between the inner and the
outer life. Edie's theory would imply that our attention is
drawn to the similarities between our inner and outer
lives. But in experience, what usually catches our atten-
tion is the difference (often the chasm!) between the two.
Often it is only the mismatch that makes us attend to
our inner lives at all.

Gabriel Marcel draws a picture of the relationship
between the inner and the outer lives which bypasses
my objections to Edie's picture.[5] Marcel would argue
that we never do experience what Edie calls "concrete
world-phenomena" without inner involvement. Because
we must live in the concrete outer world, our psycholog-
ical and emotional lives operate on that world. The
outer world is never "concrete"; rather, it is rendered
"indistinct" (to use Edie's word), sometimes even
obscure, by the pressures of inner life. Our aspirations,
our emotional ties, our attempts to find meaning direct
us (and sometimes make us unable accurately) to see
and respond to particular events.

But Marcel would not want to replace Edie's picture
of the relationship between (speech about) our inner
and outer worlds with its simple inverse. Marcel would
not want to suggest that we grasp the indistinct outer
world by means of metaphors drawn from a relatively
distinct inner world. Rather, Marcel argues that our
inner lives are not revealed to us unproblematically
either. Imagine, he writes, trying to capture the essence
of a person's life posthumously. Would you say the per-
son's inner life is revealed in her or his diaries? In her or
his professional accomplishments? In the personalities

of her or his children? In the changes that will be effected in the lives of people who loved the deceased? But this line of questioning introduced by Marcel misses what some consider to be the most important feature of inner life, that it is private. So I would encourage you to think about what reveals *your* inner life *to you*. Does it become clear to you when you write to yourself or speak with close friends? Does it become problematic to you as you consider your accomplishments, or as you evaluate your children? Does it present itself to you when you think about your relationships with others?

As I consider each of these possibilities, two insights occur to me. The first insight is made much of by Marcel: each of these descriptors offers only a partial view of the inner life of a person. And Marcel believes that we never can achieve more than a partial perspective on our inner lives. In this view, he implicitly contradicts the view of Edmund Husserl, founder of the phenomenological movement, who wrote that what distinguishes physical objects from psychic objects is the fact that physical objects are only revealed to us through a series of perspectival views located at various points in space and time. By contrast, Husserl thought that inner experiences are revealed to us as totalities, without multiple perspectives; that when we feel an emotion or think a thought, it presents itself to us in its entirety.[6] But Husserl's theory tears emotions and thoughts out of their context. In reality they are intertwined with so-called "outside" events in complex ways. Rarely do we understand why we have emotions or what to do with them. And sometimes we cannot even identify them!

This brings me to the second insight implicit in Marcel's meditation on grasping the inner life. We use concrete events, persons, and objects in order to make explicit our inner lives. We seem to "attach" our thoughts and feelings to outer phenomena in our attempts to articulate, understand, and sometimes

change our thoughts and feelings. In Marcel's picture of the relationship between inner and outer life, the inner life gives shape to the outer life and the outer life gives shape to the inner life. To go back to Denton's definition of metaphor, for Marcel the inner and outer lives are metaphorical representations of each other, as they are used to grasp each other.

An Argument from Empiricist Epistemology

Above I painted a picture of human experience using rather broad strokes. But Marcel's conclusion can also be argued for in terms of an epistemology which identifies the basic building blocks of human experience. Using an argument grounded in a canonical philosophical text, Paul de Man does just that.[7] As a deconstructionist, de Man accepts Derrida's view that language creates an illusion of presence. By deconstructing a philosophical text, he shows that the presence (the theory) of which the text speaks is an illusion.[8] In order to make his point that inner and outer life are metaphors for grasping one another, de Man attempts to deconstruct John Locke's major work on epistemology, *An Essay Concerning Human Understanding.*[9] In the *Essay*, Locke's stated view is that our experience of the outer world provides the foundation for *all* of our experience, including our inner experience. De Man's aim in deconstructing Locke's text is to show that Locke's text, when read carefully, also reveals the opposite of what it claims to support: that our experience of the inner world provides the foundation for our outer experience.

According to Locke, simple ideas of sensation, which are experiences of sensory qualities (such as "red," "sweet," and "loud") in the outside world, present themselves to us in their entirety; we cannot break them down or inquire into their components. Our minds combine and compare simple ideas in order to form

complex ideas (such as "apple"). As our minds operate on the ideas of sensation, we develop ideas about our minds, which Locke calls "ideas of reflection." The origins of particular ideas of reflection can, theoretically, be traced to operations on particular simple ideas of sensation.[10]

In his discussion of simple ideas, Locke points out that the simple idea of "motion" is defined by scientists of his day as "a passage from one place to another," although "passage" can only be defined as "motion." Locke uses this fact to support his view that "the names of simple ideas are not capable of any definitions."[11] However, de Man thinks that Locke has actually offered evidence for the view that simple ideas can only be defined in terms of other simple ideas. In this case the names of simple ideas would be examples of what Locke calls "figurative language" (and what we today call "metaphorical language") which Locke defines as language which names or describes a thing in terms of something else. This view of simple ideas undermines Locke's stated view that we apprehend simple ideas immediately and directly. If language is the way that we make our knowledge explicit, then simple ideas are not known in and of themselves. Since, for Locke, all knowledge is built out of simple ideas, everything we know is known in terms of something else.

Even the two basic categories of Locke's epistemology, the "mind" which knows and the "world" which is known, must then be metaphorical, i.e., defined in terms of something else. And for Locke this is so: because the mind comes to know itself through experience of the world, the mind is defined implicitly as "the place where experience of the world occurs." Because the world is known to us only as we experience it, the world is defined implicitly as "that which is grasped by the mind." "Mind" and "world" are understood in terms of one another and so are also metaphorical concepts. To restate this using the terms I've employed throughout

the essay: what we know of the outer world is our attempt to express what is inside. What we know of the inner world is a reflection of what we know of the outer world.

The Thesis as Metaphor: Taking It Up into My Life

Now that I have completed a two-step philosophical argument to make a point about the nature of the human psyche, I am haunted by Soren Kierkegaard's question about philosophy: How am I to take it up into my life?[12] There are many possible ways, but for the sake of brevity I shall suggest only one application of the thesis, an integration of its insight into political commitments.

Essayist and social critic Susan Griffin has recently published a book about the history of World Wars I and II entitled *A Chorus of Stones: The Private Life of War.*[13] In each chapter Griffin tells several stories simultaneously: she follows the public careers of military leaders, peace activists, and scientists; reconstructs their personal lives through letters, diaries, and interviews; imagines intimate and often chilling details which are not usually a part of historical or personal accounts; and meditates on her own family history as it unfolded during the same era.

As I read those stories, it was at first difficult for me to see why Griffin lets the reader wander through a confusing confluence of story lines. But I read patiently, confident that the relationship between the various stories would be revealed. And it was. Griffin finally makes clear by both showing and saying that, in an honest account of experience, the different stories cannot be told separately. In reality, the inner stories, the outer stories, the personal stories, the historical stories all mutually create one another. In the stories of her heroes and

antiheroes (for example, nonviolent activist Mohandas Gandhi, atomic scientist Enrico Fermi, Nazi SS director Heinrich Himmler), adjustments to the inner life made in youth in order to cope with family or personal circumstances became the basis for outer adult life choices later. And the chilling results of those outer choices—personal aspirations fulfilled and unfulfilled, the deaths and sufferings of thousands ordered and witnessed—required further adjustments to the inner life.

Griffin's inclusion of her own family history within the nexus of stories shows that her thesis is no less true of us than it is of her protagonists. Our own inner lives are marked by historical events, as we try to reconcile ourselves morally and practically to them. We are the stones in the book's title "A Chorus of Stones." We understand more than we let on about the causes and effects of war, because our psyches shape them and are shaped by them. Griffin's understated call to action is for us to stop pretending that war is the inevitable result of a confluence of outer events over which we have no control and for us to examine our inner lives and say what we find there about the moral, psychological, and political web of war.

As a professional philosopher, my inner and outer lives have become oddly inverted. Abstract ruminations about the meaning of life, society, God, and humanity make up the concrete coinage of my daily professional work. What for most people constitutes a deep dive into the inner life is for me a superficial glide along the surface of my outer life. And it is tempting, as a professional philosopher, to allow my work to remain superficial, to spin creative abstract theories about war and peace in response to the abstract theories of others. This way I avoid the risk of being charged with not really believing in the ideas currently most likely to be published. When I do so, however, my work tells only the story of the latest fickle trends in my academic discipline. It does not

confront my inner life, my aspirations, emotional ties, or attempts to find meaning. It does not inquire seriously into the ways in which my own thoughts sabotage my ideals for peace. Worse, it hides those self-conceptions that lead to violence, direct, structural, and institutional. My telling of my own stories may well reveal how parochial my own perspectives are, how far they lead away from justice. But at least I have told those stories and opened the possibility of serious practical critique. At least I have chosen not to hide behind abstract but academically acceptable jargon which, if I use it correctly, masks all my personal confusions and imperfections, makes me appear to have actualized all of my ideals.

To all philosophers, I recommend this storytelling, this blending of outer and inner lives, of concrete routines with abstract thought about their larger meanings, of professional philosophy with genuine inner reflection. For as Griffin points out, when we choose outer over inner and tell only a political story or choose inner over outer and tell only a personal story, we are not telling enough of the story. For the inner life has a story to tell about the outer, and the outer life has its stories to tell about the inner. And, as Paul de Man's deconstruction of Locke implies, adequate knowledge of any subject should include knowledge of both.

Notes

1. David E. Denton, "That Mode of Being Called Teaching," in *Existentialism and Phenomenology in Education*, ed. David E. Denton (New York: Teachers College Press, 1974), 99–115.

2. Jacques Derrida, "Différance," in *Deconstruction in Context*, ed. Mark C. Taylor (Chicago: University of Chicago Press, 1986), 396–420.

3. James Edie, "Expression and Metaphor," *Philosophy and Phenomenological Research* 23, no. 193 (1962): 538–61.

4. Maurice Merleau-Ponty, *Phenomenology of Perception*, trans. Colin Smith (New York: Humanities Press, 1962), 5.

5. Gabriel Marcel, *The Mystery of Being,* vol. 1, *Reflection and Mystery* (Chicago: Henry Regnery Company, 1950), 148–70.

6. Edmund Husserl, *Ideas: General Introduction to Pure Phenomenology* (New York: Macmillan, 1956), 117–32.

7. Paul de Man, "The Epistemology of Metaphor," in *On Metaphor,* ed. Sheldon Sacks (Chicago: University of Chicago Press, 1979), 11–28.

8. For a clear account of what it means to "deconstruct" a text, see David Hoy, "Jacques Derrida," in *The Return of Grand Theory in the Human Sciences,* ed. Quentin Skinner (New York: Cambridge University Press, 1985), 41–64.

9. John Locke, *Essay Concerning Human Understanding,* in *Classics of Western Philosophy,* ed. Stephen Cahn (Indianapolis: Hackett, 1977).

10. Ibid., book 1.

11. Ibid., book 3.

12. Soren Kierkegaard, *The Journals of Soren Kierkegaard,* excerpted in *Ethics,* 5th ed., ed. Oliver A. Johnson (New York: Holt, Rinehart, and Winston, 1984), 236.

13. Susan Griffin, *A Chorus of Stones: The Private Life of War* (New York: Doubleday, 1992).

Index

142 *Family Pictures*